Ending Wokeness

By

Yirmyah Fox

8/2/24

ChurchofCrypto.online

Chapter 1: Awakening to the New Norms

Chapter 2: The Silencing Effect

Chapter 3: The Classroom Battlefield

Chapter 4: Media's Role in Shaping Perceptions

Chapter 5: Corporate Conformity

Chapter 6: The Cultural Divide

Chapter 7: The Erosion of Meritocracy

Chapter 8: The Legal Landscape

Chapter 9: Science and Objectivity Under Siege

Chapter 10: The Influence on Arts and Literature

Chapter 11: Religion and Wokeness

Chapter 12: Family and Personal Relationships

Chapter 13: The Psychological Impact

Chapter 14: The Global Perspective

Chapter 15: Resistance and Backlash

Chapter 16: Pathways to Balance

Chapter 17: Envisioning a Post-Woke Future

Chapter 1: Awakening to the New Norms

In the heart of our social landscape, where conversations and interactions flow like rivers through the valleys of human experience, a new and insidious ideology took root and grew unchecked: wokeness. The term itself, originally a noble call to awareness of societal injustices, has been hijacked and twisted into a weapon of conformity and censorship. This chapter is not just an exploration but a battle cry to dismantle this destructive force that threatens the very fabric of our society.

Wokeness didn't emerge overnight. It was a slow burn, a quiet revolution that gradually infiltrated every aspect of our lives. It began with a genuine desire for justice and equality, drawing from historical movements that fought against oppression and discrimination.

However, somewhere along the line, this well-meaning pursuit was co-opted by a

fervent zealotry that demands absolute adherence to its dogma. The initial whispers of awareness morphed into a deafening roar, drowning out any dissenting voice.

The origins of wokeness can be traced back to the post-Civil Rights era when society began to reckon with its past injustices. However, what began as a call for equal rights transformed into a movement that judges individuals not by their character but by their adherence to a rigid set of ideological principles. The irony is stark: a movement that started to end discrimination now perpetuates it under a different guise, demanding conformity and punishing any deviation.

Social media was the perfect breeding ground for wokeness. Platforms like Twitter and Facebook became echo chambers where like-minded individuals amplified each other's outrage. The algorithms, designed to promote engagement, inadvertently fanned the flames of this ideological wildfire.

Hashtags became battle cries, and retweets and likes became measures of moral superiority. The digital landscape transformed into a battleground where only the most extreme voices could be heard.

The rise of wokeness was marked by key events that galvanized its followers. The shooting of Michael Brown in Ferguson and the subsequent Black Lives Matter movement were pivotal moments. These events highlighted real issues of racial injustice, but they also provided a platform for wokeness to assert its dominance. The #MeToo movement, too, brought necessary attention to sexual harassment and assault, but it also showcased the darker side of wokeness: the rush to judgment, the destruction of due process, and the vilification of any perceived offender without a fair trial.

Wokeness infiltrated education, turning classrooms into indoctrination centers. Schools and universities adopted curricula

that emphasized identity politics over critical thinking. The aim was no longer to educate but to mold young minds into ideological warriors. Dissenting voices were silenced, and intellectual diversity was sacrificed at the altar of ideological purity. Students were taught to see the world through a lens of victimhood and oppression, creating a generation ill-equipped to handle complex, nuanced realities.

The corporate world, ever the opportunist, jumped on the woke bandwagon with gusto. Companies rebranded themselves as champions of social justice, more interested in virtue signaling than genuine change. Marketing campaigns became exercises in pandering to woke sensibilities, often at the expense of alienating their broader customer base. It was a curious paradox: corporations known for their exploitative practices now posing as moral arbiters of society.

The media, always eager for a compelling narrative, amplified the woke agenda. News outlets, both traditional and digital, found that wokeness drove clicks and views. Stories were framed to fit the woke narrative, and any deviation from this script was either ignored or condemned. The media landscape became a minefield, where stepping out of line could result in public shaming and ostracism. Journalists and commentators who dared to question the woke orthodoxy found themselves marginalized or out of a job.

Politicians, sensing the changing tides, quickly adapted. Wokeness became a political tool, wielded to gain favor with a vocal segment of the electorate. Policies and rhetoric were crafted to align with woke principles, often to the detriment of practicality and broader appeal. It was a delicate dance, balancing the demands of woke activists with the realities of governance. The result was a political climate where pandering to wokeness often took precedence over effective leadership.

The cultural impact of wokeness cannot be overstated. It created a divide, a chasm between those who embraced its doctrines and those who resisted. Families were torn apart, friendships strained, and workplaces became battlegrounds of ideological warfare. The demand for ideological purity led to a culture of call-outs and cancellations, where one misstep could result in social and professional excommunication. The fear of being labeled a bigot or an oppressor stifled genuine dialogue and debate.

The psychological toll of wokeness is profound. Living in a state of constant vigilance, where every word and action is scrutinized for potential offense, is exhausting. The pressure to conform to an ever-changing set of rules creates anxiety and stress. People are afraid to speak their minds, to ask questions, or to challenge the status quo. The result is a society where fear

and conformity stifle creativity, innovation, and progress.

Yet, amid the chaos and confusion, there is hope. There are voices of reason, individuals and groups who are pushing back against the excesses of wokeness. They advocate for a return to genuine discourse, where differing opinions are respected and debated, not silenced and condemned. They call for a balance, where the pursuit of justice does not come at the expense of freedom and individuality.

The future of wokeness is uncertain. It may continue to evolve, shedding its more extreme elements and finding a more moderate path. Or it may implode under the weight of its own contradictions. Whatever the outcome, one thing is clear: wokeness has left an indelible mark on our society. Its legacy will be debated for years to come, a testament to the power of ideas to shape the world.

In this chapter, we have traced the rise of wokeness, from its humble beginnings to its current dominance. We have examined its impact on various facets of society, from education to media to politics. And we have pondered its future, the potential for both transformation and turmoil. As we move forward, let us remember the lessons of wokeness, both its triumphs and its transgressions. For in understanding its journey, we can better navigate our own.

The story of wokeness is far from over. It is a living, breathing phenomenon, constantly evolving and adapting. It challenges us to think critically, to question our assumptions, and to engage with the world in a deeper, more meaningful way. Whether we embrace it or reject it, wokeness demands our attention. It is a reflection of our times, a mirror held up to our collective consciousness. And in that reflection, we see both our potential and our peril.

Let us carry forward the spirit of inquiry and reflection. We must strive for a society that values justice and fairness, but also cherishes freedom and diversity of thought. For in balancing these ideals, we can create a world that is truly awake – not just to the injustices of the past, but to the possibilities of the future.

Chapter 2: The Silencing Effect

The stage is set: a bustling marketplace of ideas where voices from every corner of the spectrum converge to exchange thoughts, argue perspectives, and challenge one another to think deeper. Or at least, that's how it used to be. Enter wokeness, like a fire-breathing dragon into this peaceful agora, scorching the landscape and leaving a smoldering wasteland of hushed whispers and nervous glances.

The vibrant cacophony of free speech has been replaced by the uneasy silence of self-censorship, as the specter of wokeness looms over every conversation.

Once upon a time, public discourse was a gladiatorial arena, a place where ideas clashed and the strongest emerged victorious. Now, it's more akin to a minefield where one wrong step can detonate your reputation, career, and social standing. The rules of engagement have

changed drastically; the emphasis is no longer on the merit of the argument but on the perceived moral purity of the speaker.

This shift has profound implications, creating an environment where people are more concerned with avoiding offense than with seeking truth.

The silencing effect of wokeness is most evident in the realm of academia, where the pursuit of knowledge should reign supreme. Universities, once bastions of free thought, have become hotbeds of ideological conformity. Professors tread lightly, students whisper in corners, and controversial speakers are disinvited or shouted down.

The marketplace of ideas has been replaced by an echo chamber, where only approved narratives are allowed to flourish. This intellectual homogeneity stifles innovation and critical thinking, the very pillars of higher education.

Consider the case of a professor who dared to question the prevailing orthodoxy. What followed was a modern-day witch hunt: protests, petitions, and social media mobs calling for his resignation. The administration, fearing backlash, caved to the pressure, and the professor was ousted.

This isn't an isolated incident; it's a pattern that has repeated itself across campuses nationwide. The message is clear: deviate from the script, and you will be punished. This culture of fear stifles academic freedom and undermines the very purpose of education.

The corporate world, too, has not been spared from the silencing effect. In boardrooms and break rooms, employees are walking on eggshells, wary of saying anything that might be deemed offensive or out of line.

Diversity training sessions, often steeped in woke ideology, have become mandatory,

reinforcing the message that there is only one acceptable way to think and speak. Companies, eager to appear virtuous, have adopted woke policies that prioritize optics over substance. This performative wokeness creates a stifling work environment where creativity and individuality are sacrificed on the altar of conformity.

Take the example of a major corporation that implemented a stringent code of conduct, dictating not only professional behavior but personal beliefs as well. Employees were required to sign pledges affirming their commitment to the company's woke values.

Those who refused or questioned the policy faced disciplinary action or termination. This Orwellian approach to corporate culture stifles dissent and discourages genuine dialogue. It reduces employees to mere automatons, reciting the company line rather than contributing their unique perspectives and ideas.

The media, traditionally the watchdogs of democracy, have become complicit in the silencing effect. News outlets, both mainstream and alternative, have succumbed to the allure of wokeness, tailoring their content to fit the prevailing narrative. Journalists who dare to report on uncomfortable truths or challenge woke dogma find themselves ostracized, their careers in jeopardy.

The result is a homogenized media landscape where critical voices are marginalized and only the most sensational, woke-friendly stories are amplified.

Consider the case of a journalist who published an investigative piece exposing corruption within a woke organization. Instead of being lauded for their courage, they faced a barrage of criticism, accusations of bias, and calls for their dismissal.

The publication, fearing backlash, issued an apology and retracted the article. This incident highlights the chilling effect wokeness has on journalism, where the pursuit of truth is sacrificed for the sake of appeasing the woke mob.

The silencing effect extends beyond professional spheres into our personal lives. Social gatherings, once lively and diverse in opinion, have become cautious affairs. Friends and family members avoid contentious topics, lest they provoke an argument or be labeled as intolerant.

This self-censorship erodes the richness of our interactions, reducing conversations to banal pleasantries devoid of depth and substance. The fear of offending others or being ostracized for one's beliefs creates an environment where authenticity and genuine connection are sacrificed.

Imagine a family dinner where politics is a forbidden topic, and every comment is carefully measured to avoid controversy. The result is a stilted, superficial interaction where the real issues that matter are never addressed.

This erosion of genuine dialogue in our personal lives mirrors the broader societal trend, where the fear of wokeness stifles free expression and meaningful engagement. The silencing effect thus permeates every level of our existence, from the public to the private, creating a culture of conformity and fear.

The implications of this suppression of dialogue are far-reaching. At its core, democracy thrives on the free exchange of ideas, where citizens can debate, disagree, and reach a consensus. Wokeness, with its demand for ideological purity and its intolerance of dissent, undermines this foundational principle.

By silencing opposing viewpoints, it creates an echo chamber where only one perspective is allowed to dominate. This monoculture stifles innovation, hinders progress, and breeds resentment among those who feel marginalized.

Moreover, the suppression of dialogue leads to a polarization of society. When people are afraid to express their true beliefs openly, they retreat into like-minded enclaves where their views are reinforced and amplified.

This balkanization of society fosters division and animosity, as each group becomes increasingly entrenched in its own worldview. The lack of open, honest conversation prevents the bridging of divides and the finding of common ground, perpetuating a cycle of conflict and mistrust.

The silencing effect also has a profound impact on mental health. The constant vigilance required to navigate the minefield of wokeness creates stress and anxiety. People are afraid to be themselves, to speak their minds, or to challenge the status quo.

This suppression of individuality takes a toll on psychological well-being, leading to feelings of isolation and disconnection. The pressure to conform to an ever-changing set of woke standards creates a sense of inadequacy and self-doubt, further exacerbating mental health issues.

In this environment, it is crucial to reclaim the lost art of conversation and to champion the values of free speech and open dialogue. This requires courage and a commitment to the principles of intellectual diversity and mutual respect. It means standing up to the woke bullies and defending the right to think and speak freely, even if it means facing criticism and backlash. It means fostering environments, whether in schools,

workplaces, or social settings, where differing opinions are valued and debated, not silenced and condemned.

One way to combat the silencing effect is to promote critical thinking and media literacy. By equipping individuals with the skills to analyze and question information critically, we can create a more informed and resilient populace. This involves teaching people to recognize biases, to seek out multiple perspectives, and to engage in thoughtful, evidence-based discussions. It also means encouraging skepticism and independent thought, rather than blind adherence to ideological dogma.

Another strategy is to support and protect those who dare to speak out against the woke orthodoxy. This can be achieved through legal measures, such as strengthening protections for free speech and whistleblowers, as well as through cultural shifts that celebrate intellectual bravery and dissent. By creating a culture

that values and rewards courage and integrity, we can encourage more individuals to challenge the silencing effect and to contribute to a vibrant, dynamic marketplace of ideas.

In addition, fostering environments that encourage open dialogue and intellectual diversity is essential. This can be done in educational institutions by promoting curricula that emphasize critical thinking and diverse perspectives, rather than ideological conformity. In the workplace, it means creating policies that protect employees' rights to free expression and that value diverse viewpoints. In our personal lives, it means engaging in conversations with those who hold different beliefs, seeking to understand rather than to condemn.

The road ahead is not easy, but it is necessary. The silencing effect of wokeness poses a significant threat to the principles of free speech and open dialogue that underpin

a healthy, functioning democracy. By recognizing and addressing this threat, we can work to restore a culture that values intellectual diversity, encourages critical thinking, and fosters meaningful, respectful conversations. In doing so, we can create a society that is truly open, vibrant, and resilient.

Ultimately, the fight against the silencing effect of wokeness is a fight for the soul of our society. It is a battle to reclaim the principles of free thought and expression, to champion the values of diversity and inclusivity in the truest sense. It is a call to arms for all those who believe in the power of dialogue and the importance of challenging orthodoxy. By standing up to the silencing effect, we can create a society that is not only more just and equitable but also more dynamic and innovative.

As we move forward, let us remember the importance of defending free speech and open dialogue. Let us strive to create

environments where differing opinions are valued and debated, where intellectual diversity is celebrated, and where individuals are free to express themselves without fear of retribution. By doing so, we can combat the silencing effect of wokeness and create a society that is truly open, vibrant, and resilient. For it is only through the free exchange of ideas that we can achieve progress, innovation, and a deeper understanding of the world around us.

Chapter 3: The Classroom Battlefield

The classroom, once a sanctuary of inquiry and enlightenment, has become a battlefield where ideological skirmishes rage with all the subtlety of a barroom brawl.

The traditional role of education—to foster critical thinking and intellectual diversity—has been hijacked by the zealous forces of wokeness. The blackboard has turned into a canvas of dogma, and the bell rings not for recess, but for indoctrination sessions.

Our educational institutions, from kindergartens to universities, are now ground zero in the culture wars, where woke ideology is both the sword and the shield.

Wokeness, like an invasive species, has infiltrated every corner of the educational ecosystem. It began innocuously enough, with well-intentioned efforts to promote

diversity and inclusion. But what started as a noble cause quickly mutated into an oppressive orthodoxy.

The curriculum, once a broad spectrum of ideas and perspectives, has been narrowed to a single, suffocating viewpoint. Subjects are no longer taught through the lens of objective analysis but through the prism of woke ideology. History is rewritten, literature is censored, and science is politicized, all in the name of social justice.

Take, for instance, the rewriting of history textbooks. Events and figures are not merely reexamined but reinterpreted to fit a woke narrative. The complexities of history are simplified into binaries of oppressors and victims.

George Washington, once hailed as a founding father, is now scrutinized primarily for his ownership of slaves.

Christopher Columbus is not an explorer but a colonizer. This reductionist approach strips historical figures of their multifaceted legacies, reducing them to mere caricatures.

It's as if we've decided that the past must conform to the moral standards of the present, erasing the nuance and context that are essential for understanding history.

Literature, too, has not been spared. Classic works are dissected for any hint of problematic content. Mark Twain's "Adventures of Huckleberry Finn" is flagged for its use of racial slurs, despite its anti-racist message.

Shakespeare's plays are scrutinized for their portrayals of gender and power dynamics. Instead of teaching students to grapple with the complexities of these texts, educators

often opt for censorship or sanitization. The result is a generation of students who are shielded from the very discomfort that literature is meant to provoke, losing out on the rich, transformative experience of engaging with challenging works.

Wokeness has introduced a new breed of ideological rigidity. Biological facts are questioned, and scientific inquiry is sometimes curtailed if it threatens to contradict woke doctrines. Discussions about sex and gender, once grounded in biological reality, have been reframed to fit ideological narratives. Scientists who dare to present findings that contradict woke beliefs risk professional ostracization.

This undermines the very foundation of scientific inquiry, which relies on questioning assumptions and following evidence wherever it leads.

The transformation of the classroom into an ideological battleground is perhaps most evident in higher education. Universities, which should be bastions of free thought and rigorous debate, have become echo chambers where dissent is not just discouraged but punished. Conservative speakers are disinvited or shouted down.

Students who express unpopular opinions are subjected to social ostracism and academic penalties. Safe spaces, trigger warnings, and microaggression training sessions have created an environment where students are coddled rather than challenged.

Consider the case of a university that implemented a mandatory sensitivity training program. The goal was to foster a more inclusive campus, but the effect was to instill a culture of hypersensitivity and self-censorship. Students were taught to see microaggressions everywhere, to interpret even the most innocuous comments as potential offenses.

This culture of victimhood not only stifles free expression but also impedes personal growth. By teaching students to avoid discomfort rather than confront it, we are depriving them of the resilience and critical thinking skills they need to navigate the real world.

The influence of wokeness in education extends beyond the classroom into the administrative policies and practices. Admissions processes have been overhauled to prioritize diversity over merit. The focus is on achieving demographic representation rather than recognizing individual achievement. This has led to accusations of reverse discrimination and has sparked legal battles over affirmative action policies.

The emphasis on identity politics in admissions undermines the principle of equal opportunity and creates a divisive environment where students are judged by their race, gender, or sexual orientation rather than their abilities and achievements.

Faculty hiring and promotion practices have also been affected. Diversity statements are now a common requirement in academic job applications, forcing candidates to demonstrate their commitment to woke principles.

This prioritization of ideological conformity over academic excellence has led to concerns about the erosion of meritocracy in academia. Professors are increasingly evaluated not just on their scholarly contributions but on their adherence to woke ideology. This shift undermines the pursuit of knowledge and discourages intellectual diversity.

The silencing of dissenting voices is perhaps the most alarming consequence of the woke takeover of education. Professors who challenge the prevailing orthodoxy risk being ostracized, harassed, or even fired. Students who express unpopular opinions

are often subject to social ostracism and academic penalties.

The fear of being labeled a bigot or an oppressor stifles genuine dialogue and critical thinking. This culture of conformity is antithetical to the mission of education, which should be to foster intellectual curiosity and open-mindedness.

One of the most insidious effects of wokeness in education is the impact it has on students' development. By prioritizing ideological conformity over critical thinking, we are depriving students of the tools they need to navigate a complex and diverse world. The focus on identity politics teaches students to see themselves and others primarily through the lens of race, gender, and sexual orientation. This reductive approach not only limits their understanding of themselves and others but also fosters a sense of division and antagonism.

The impact of wokeness on students' mental health is another cause for concern. The constant emphasis on microaggressions and perceived slights creates a culture of hypersensitivity and victimhood. Students are taught to interpret even the most innocuous comments as potential offenses, leading to heightened anxiety and stress.

This culture of fragility undermines students' resilience and ability to cope with adversity. Instead of preparing students for the challenges of the real world, we are coddling them and fostering a sense of helplessness.

Despite these challenges, there are glimmers of hope. There are educators, administrators, and students who are pushing back against the woke orthodoxy and advocating for a return to the principles of free thought and intellectual diversity. They are calling for an education system that values merit and achievement, that encourages critical

thinking and open dialogue, and that fosters resilience and personal growth. By supporting these efforts, we can begin to reclaim our educational institutions and create a more balanced and inclusive learning environment.

To combat the influence of wokeness in education, it is essential to promote a culture of intellectual diversity and open dialogue. This means creating spaces where students and faculty feel free to express their opinions and engage in robust debate without fear of retribution. It means valuing merit and achievement over identity politics and prioritizing the pursuit of knowledge over ideological conformity. It also means fostering resilience and critical thinking skills, preparing students to navigate the complexities of the real world.

One practical step in this direction is to review and revise curricula to ensure that they reflect a broad range of perspectives and ideas. This means including works from

diverse authors and scholars, but not at the expense of intellectual rigor. It means teaching students to engage critically with challenging texts and ideas, rather than shielding them from discomfort.

By exposing students to a wide range of viewpoints and encouraging them to think critically, we can help them develop the skills they need to navigate a complex and diverse world.

Another important step is to promote policies and practices that prioritize merit and achievement. This means reevaluating admissions processes to ensure that they are fair and transparent, and that they recognize individual achievement rather than identity. It means supporting faculty hiring and promotion practices that value scholarly contributions and intellectual diversity over ideological conformity.

By fostering a culture of meritocracy, we can create an environment where excellence is rewarded and where all students have the opportunity to succeed.

It is also essential to protect the rights of students and faculty to free speech and academic freedom. This means standing up against efforts to silence dissenting voices and creating policies that protect individuals from harassment and discrimination based on their opinions.

It means fostering a culture of respect and civility, where differing viewpoints are debated and discussed rather than silenced and condemned. By protecting the principles of free speech and academic freedom, we can create a more vibrant and dynamic learning environment.

The influence of wokeness in education is a profound and multifaceted challenge. It has transformed our educational institutions into

battlegrounds of ideological conformity, stifling intellectual diversity and free thought.

It has impacted curricula, teaching practices, admissions processes, faculty hiring, and student development. However, by recognizing these challenges and advocating for a return to the principles of free thought, intellectual diversity, and meritocracy, we can begin to reclaim our educational institutions and create a more balanced and inclusive learning environment.

This is not just a battle for the classroom, but for the very future of our society.

Chapter 4: Media's Role in Shaping Perceptions

The media, that magnificent beast, has always held the power to shape our perceptions, molding the collective consciousness like a potter with a particularly pliable lump of clay. In this era of wokeness, the media has donned a new mantle—not just a storyteller but a crusader, wielding its influence like a knight wielding a broadsword. Its role in propagating woke narratives is profound, and the implications for public opinion are both vast and insidious.

We begin with the news media, that once hallowed institution dedicated to the noble pursuit of truth.

These days, it's more akin to a carnival barker, luring the masses with sensational headlines and lurid tales of societal woe. The newsroom, traditionally a place of

rigorous debate and investigation, has morphed into an echo chamber where woke ideology is not just reported but celebrated.

Journalists who dare to question the prevailing orthodoxy find themselves ostracized, their careers hanging by a thread.

Take, for example, the coverage of protests and social justice movements. The media paints these events with a broad, sympathetic brush, often glossing over the more unsavory aspects. Riots become "mostly peaceful protests," and looting is rebranded as a legitimate expression of frustration. This selective reporting creates a distorted reality, where the complexities of social issues are simplified into black-and-white morality plays. The public, fed a steady diet of one-sided narratives, loses the ability to see the full picture.

The entertainment industry, ever the chameleon, has also embraced the woke

agenda with open arms. Hollywood, that glittering bastion of excess and escapism, now churns out films and television shows laden with woke messaging.

Scripts are scrutinized for diversity and inclusivity, characters are reimagined to fit contemporary ideals, and entire genres are retooled to reflect woke values. The result is a cultural landscape where entertainment is no longer just about storytelling but about delivering a sermon.

Consider the transformation of superhero movies, once simple tales of good versus evil. Today, these films are packed with social commentary, often to the detriment of plot and character development.

Heroes are recast to ensure a diverse ensemble, villains are given woke motivations, and every scene is imbued with a sense of moral urgency. While these changes may reflect a more inclusive

society, they also risk alienating audiences who crave escapism over indoctrination. The box office, after all, is not immune to the laws of supply and demand.

Social media platforms, those digital town squares, have become the primary battleground for woke culture. Algorithms designed to maximize engagement have inadvertently amplified the most extreme voices, turning every debate into a gladiatorial contest. The currency of this realm is outrage, and wokeness is its most valuable commodity. Posts and tweets that align with woke ideology are rewarded with likes, shares, and retweets, creating a feedback loop that perpetuates the narrative.

Take the phenomenon of "cancel culture," where individuals are publicly shamed and ostracized for transgressions against woke norms. Social media platforms are the staging grounds for these digital witch hunts, where accusations fly fast and loose, and the mob mentality reigns supreme.

The consequences are real and often devastating: careers ruined, reputations shattered, and lives upended. The chilling effect on free speech is palpable, as people self-censor for fear of becoming the next target.

The mainstream news media, in its quest for relevance, has not shied away from capitalizing on the woke wave. Traditional journalism's golden rule of objectivity is increasingly sacrificed at the altar of advocacy. News outlets, both on the left and the right, tailor their coverage to fit their audience's ideological leanings, creating parallel universes of information. This bifurcation of news consumption fosters polarization, as people retreat into media silos that reinforce their preexisting beliefs.

One cannot ignore the economic incentives driving this trend. Media companies, facing

declining revenues and intense competition, have discovered that wokeness sells.

Controversial stories, framed through a woke lens, generate clicks, shares, and advertising dollars. The pursuit of profit, always a key motivator, now intersects with ideological alignment, creating a potent brew that shapes editorial decisions. The line between news and opinion blurs, as sensationalism trumps substance.

The role of media conglomerates in this landscape is particularly noteworthy. These behemoths, with their vast portfolios of news, entertainment, and digital platforms, wield immense influence over public perception.

Their corporate strategies increasingly reflect woke priorities, from diversity initiatives to content policies. This top-down approach ensures that the woke narrative permeates every level of media

consumption, from prime-time news to children's programming.

The media's embrace of wokeness is not without its critics. Dissenting voices argue that this ideological conformity stifles diversity of thought and undermines journalistic integrity. They point to instances where important stories are ignored or downplayed because they don't fit the woke narrative.

The media's focus on identity politics, they argue, distracts from more pressing issues like economic inequality, climate change, and geopolitical conflicts. These critics call for a return to the principles of objective reporting and balanced coverage.

The media's influence extends beyond shaping perceptions to setting the agenda for public discourse. By choosing which stories to highlight and how to frame them, the

media dictates what issues dominate the national conversation.

In the age of wokeness, this agenda-setting power is wielded to advance specific ideological goals. Issues of race, gender, and identity are foregrounded, while other topics receive less attention. This selective focus shapes public priorities and policy debates, reinforcing the woke agenda at every turn.

The entertainment industry's role in this dynamic is equally significant. Popular culture, through movies, television shows, music, and literature, reflects and reinforces societal norms and values. When entertainment becomes a vehicle for woke ideology, it influences how people see the world and their place in it.

This is particularly impactful for younger audiences, who are still forming their identities and beliefs. The normalization of woke values in entertainment helps to

entrench these ideas in the cultural consciousness.

Education and media are two sides of the same coin in the propagation of wokeness. The narratives taught in schools are reinforced by the stories told in the media.

Together, they create a comprehensive framework that shapes how individuals understand social issues and their own identities. This symbiotic relationship amplifies the reach and impact of woke ideology, embedding it deeply in the fabric of society.

The consequences of this media-driven wokeness are profound. It fosters a culture of conformity, where deviation from the woke orthodoxy is punished. It polarizes society, creating divisions based on identity and ideology. It undermines trust in the media, as people become skeptical of news that seems more interested in advocacy than

accuracy. It also stifles creativity and innovation in the entertainment industry, as creators feel constrained by the need to adhere to woke standards.

Yet, amidst the pervasive influence of wokeness in the media, there are glimmers of resistance. Independent journalists and media outlets are pushing back against the dominant narrative, offering alternative perspectives and challenging the status quo. These mavericks are carving out spaces for genuine dialogue and critical thinking, often at great personal and professional risk. Their efforts represent a crucial counterbalance to the monolithic woke agenda, reminding us of the importance of diversity of thought.

As consumers of media, we have a role to play in this battle. By seeking out diverse sources of information, critically evaluating the news we consume, and supporting independent media, we can resist the homogenizing influence of wokeness.

Media literacy is more important than ever, as we navigate a landscape where misinformation and ideological bias are rampant. By becoming more discerning consumers of media, we can help to foster a more informed and open society.

The road to ending the media's role in propagating woke culture is long and fraught with challenges. It requires a concerted effort from journalists, media executives, creators, and consumers alike. It demands a recommitment to the principles of free speech, intellectual diversity, and journalistic integrity.

It calls for a rejection of the sensationalism and ideological conformity that have come to dominate the media landscape.

The media's role in shaping perceptions through the lens of wokeness is both powerful and pervasive. It influences how we understand social issues, shapes public

opinion, and sets the agenda for national discourse.

This chapter has explored the various ways in which news, entertainment, and social media platforms contribute to this dynamic, highlighting the challenges and consequences of a media landscape dominated by woke ideology. By recognizing these influences and actively seeking to counter them, we can work towards a more balanced and diverse media environment. This is not just a fight for the soul of the media but for the very principles of free thought and expression that underpin a healthy, functioning democracy.

Chapter 5: Corporate Conformity

In the high-rise fortresses of capitalism, where profit margins reign supreme and the bottom line is sacrosanct, a curious transformation is underway. Corporations, once bastions of cold efficiency and unbridled ambition, have donned the garb of social justice warriors.

The boardrooms are now filled with buzzwords like "diversity," "inclusivity," and "equity," and the quarterly reports are peppered with proclamations of virtue. Welcome to the era of corporate wokeness, where the giants of industry have swapped their pinstripes for moral halos, all while keeping one eye firmly on the stock ticker.

The motivations behind this corporate embrace of wokeness are as multifaceted as a Rubik's Cube, and just as twisted. At first glance, it seems like a noble endeavor—a sincere effort to right societal wrongs and

foster a more equitable world. But peel back the layers, and a different picture emerges. Beneath the surface lies a calculated strategy driven by profit, public relations, and a hefty dose of self-preservation.

It's less about genuine social change and more about staying ahead of the cultural curve and avoiding the wrath of the woke mob.

Consider the spectacle of major corporations tripping over themselves to out-woke each other. When one company pledges to diversify its board of directors, another responds by promising to overhaul its entire supply chain to support minority-owned businesses. It's a race to the top of the virtue signaling mountain, where the prize is not just social capital but real, tangible benefits.

Positive media coverage, increased consumer loyalty, and the elusive but highly coveted status of being on the "right side of

history." It's a high-stakes game, and the players are nothing if not shrewd.

Take the case of a multinational conglomerate that recently rolled out a comprehensive diversity and inclusion initiative. The announcement was met with widespread acclaim, but the fine print revealed a different story. The initiative was largely cosmetic, with little substance beyond flashy slogans and token gestures.

The real goal was to deflect criticism and preempt any potential backlash. By presenting a facade of wokeness, the company hoped to insulate itself from scrutiny and maintain its market position. It's a classic bait-and-switch, wrapped in the rhetoric of social justice.

The impact of this corporate conformity extends far beyond the boardroom. It permeates every facet of business practice, from hiring policies to marketing strategies.

Job candidates are now evaluated not just on their skills and experience, but on their alignment with the company's woke values.

The hiring process has become a minefield, where one wrong move or perceived misstep can derail a promising career. Meanwhile, marketing campaigns are meticulously crafted to appeal to the woke sensibilities of consumers, often at the expense of authenticity and creativity.

Consider the phenomenon of "woke-washing," where companies use social justice rhetoric to sell products and services. It's a savvy marketing tactic, designed to tap into the growing consumer demand for brands that align with their values. But it also raises ethical questions about the sincerity of these efforts.

Are companies truly committed to social change, or are they simply exploiting the latest trend for profit? The answer, more

often than not, lies somewhere in the gray area between genuine intent and opportunistic maneuvering.

One of the most striking examples of woke-washing is the rise of purpose-driven branding. Companies now position themselves as champions of social causes, from environmental sustainability to gender equality.

Advertising campaigns are infused with messages of empowerment and activism, creating an emotional connection with consumers. But behind the glossy veneer lies a more cynical reality. These campaigns are meticulously designed to drive sales and enhance brand loyalty, often with little regard for the actual impact on the causes they purport to support.

The influence of corporate wokeness extends to the consumer landscape, shaping purchasing behavior and brand loyalty. Today's consumers, particularly millennials

and Gen Z, are more socially conscious than ever before. They seek out brands that reflect their values and are willing to pay a premium for products that align with their beliefs.

Corporations, ever attuned to market trends, have responded by adopting woke principles and integrating them into their business models. It's a symbiotic relationship, where consumer demand drives corporate behavior, and vice versa.

But this alignment of corporate and consumer interests is not without its pitfalls. The emphasis on woke branding can lead to a homogenization of products and services, where innovation and differentiation take a backseat to virtue signaling.

Companies become more focused on projecting the right image than on delivering quality and value. This can result in a dilution of brand identity, as businesses

scramble to keep up with the ever-evolving standards of wokeness. The pressure to conform can stifle creativity and risk-taking, undermining the very principles of free enterprise.

Moreover, the rise of corporate wokeness has implications for the broader economic landscape. As companies prioritize social justice initiatives, they may divert resources away from core business functions, impacting productivity and growth. The focus on diversity and inclusion can also create tension within organizations, as employees navigate the complex dynamics of identity politics.

While these initiatives can foster a more inclusive workplace, they can also breed resentment and division if not implemented thoughtfully and transparently.

The question of authenticity looms large in the world of corporate wokeness.

Consumers are increasingly savvy, and they can spot insincerity from a mile away. Companies that engage in performative activism without backing it up with meaningful action risk alienating their customer base.

The backlash can be swift and severe, as consumers call out perceived hypocrisy and demand accountability. This has led to a new era of corporate transparency, where businesses are expected to demonstrate their commitment to social causes through concrete actions and measurable results.

One notable example is the backlash faced by a major tech company after it was revealed that its much-publicized diversity efforts were largely superficial. Despite lofty promises and high-profile hires, the company had made little progress in addressing systemic issues within its workforce.

The revelation sparked a firestorm of criticism, with employees and consumers alike demanding real change. The company was forced to reassess its approach and implement more substantive reforms, highlighting the importance of authenticity in the age of corporate wokeness.

The rise of corporate wokeness has also sparked a broader conversation about the role of business in society. Traditionally, the primary responsibility of a corporation was to its shareholders, with profit as the ultimate goal.

The advent of woke capitalism has shifted this paradigm, as companies are increasingly expected to play a role in addressing social and environmental issues. This has led to the emergence of stakeholder capitalism, where businesses consider the interests of all stakeholders—employees, customers, communities, and the environment—alongside those of shareholders.

This shift has profound implications for the future of capitalism. On one hand, it represents a more holistic and sustainable approach to business, one that recognizes the interconnectedness of economic and social systems. On the other hand, it raises questions about the limits of corporate responsibility and the potential for overreach.

As companies take on more social and environmental roles, they may find themselves navigating complex ethical dilemmas and facing increased scrutiny from all sides.

The debate over corporate wokeness is not just about business practices but also about the broader cultural and political landscape. As corporations become more vocal on social issues, they inevitably wade into the murky waters of politics. This has led to a growing tension between business and

government, as companies advocate for policies that align with their woke values.

The result is a complex and often contentious relationship, where corporations wield significant influence over public policy and political discourse.

One of the most visible manifestations of this dynamic is the role of corporate lobbying. Companies have long engaged in lobbying efforts to shape legislation and regulation in their favor. But in the age of wokeness, these efforts have taken on a new dimension, as businesses push for policies that reflect their social justice commitments. This has led to a blurring of the lines between corporate interests and public policy, raising concerns about the impact on democratic processes and accountability.

The influence of corporate wokeness extends to the realm of employee relations as well. Companies are increasingly

expected to create inclusive and supportive workplaces, where diversity is not just tolerated but celebrated. This has led to the proliferation of diversity and inclusion programs, employee resource groups, and sensitivity training sessions.

While these initiatives can foster a more equitable work environment, they can also create new challenges, as employees navigate the complexities of identity politics and cultural change.

One example is the rise of unconscious bias training, a popular but controversial tool in the corporate diversity toolkit. These training sessions aim to raise awareness of implicit biases and promote more inclusive behavior.

However, critics argue that they can be counterproductive, reinforcing stereotypes and creating a sense of division rather than unity. The effectiveness of these programs

remains a topic of debate, as companies grapple with the best ways to foster genuine inclusivity and address systemic issues.

The impact of corporate wokeness on consumer behavior is another key aspect of this phenomenon. Today's consumers are more informed and discerning than ever before, and they increasingly expect companies to align with their values. This has led to the rise of ethical consumerism, where purchasing decisions are influenced by social and environmental considerations.

Brands that fail to meet these expectations risk losing market share and customer loyalty, while those that successfully navigate the woke landscape can reap significant rewards.

One notable example is the success of companies that have embraced sustainability and environmental responsibility. Brands like Patagonia and Ben & Jerry's have built

loyal followings by aligning their business practices with their social and environmental commitments.

These companies have demonstrated that it is possible to balance profit and purpose, creating value for both shareholders and society. However, the challenge lies in ensuring that these efforts are genuine and not merely a marketing ploy.

The rise of corporate wokeness also has implications for corporate governance and leadership. CEOs and executives are increasingly expected to take public stances on social issues, and their actions are scrutinized through the lens of woke values. This has led to a new era of activist leadership, where business leaders are not just stewards of their companies but also advocates for broader social change. While this can be a powerful force for good, it also raises questions about the limits of corporate influence and the potential for mission creep.

The case of a prominent CEO who faced backlash for his company's stance on a controversial social issue illustrates the challenges of navigating corporate wokeness. The CEO's public statements sparked a firestorm of criticism, with employees, customers, and shareholders all weighing in on the debate. The incident highlighted the delicate balance that business leaders must strike between staying true to their values and managing the diverse expectations of their stakeholders.

The phenomenon of corporate wokeness is complex and multifaceted, with far-reaching implications for business, society, and culture. As companies continue to navigate this landscape, they must grapple with the challenges and opportunities it presents.

Understanding the motivations behind corporate wokeness and its impact on business practices and consumer behavior,

we can better appreciate the dynamics at play and work towards a more balanced and equitable future.

Corporate wokeness is a double-edged sword, offering both potential benefits and significant challenges. While the adoption of woke principles can drive positive social change and enhance brand loyalty, it also risks undermining authenticity, stifling innovation, and creating division.

It is essential to critically examine the role of corporations in society and to strive for a balance that respects the principles of free enterprise while promoting social and environmental responsibility. This is not just a challenge for businesses but for all of us, as we navigate the complex and ever-evolving landscape of woke culture we must destroy it.

Chapter 6: The Cultural Divide

The cultural landscape of the 21st century resembles a war-torn battlefield more than a melting pot. The trenches are dug deep, and the no-man's-land between opposing sides is littered with the remnants of civil discourse.

The advent of wokeness has played a pivotal role in this seismic shift, driving a wedge between communities and setting the stage for a society that's more polarized than ever before. This chapter will take you on a harrowing journey through the cultural rifts created by woke ideology and explore potential strategies to bridge these divides and restore some semblance of unity.

Imagine wokeness as a viral contagion, spreading with alarming speed and leaving chaos in its wake. It infiltrates every corner of society, from urban centers to rural outposts, igniting passions and provoking conflicts. Communities once united by

shared values and common goals find themselves splintered, with neighbors eyeing each other suspiciously from behind ideological barricades.

The battle lines are drawn, and the casualties are many—friendships, family bonds, and the very fabric of social cohesion.

At the heart of the cultural divide is the clash between traditional values and progressive ideals. On one side, you have those who cling to long-held beliefs and customs, viewing them as the bedrock of a stable society.

On the other, you have the champions of wokeness, who see these same traditions as relics of an oppressive past that must be dismantled to make way for a more equitable future. This fundamental disagreement fuels a cycle of resentment and retaliation, each side feeling under siege and increasingly entrenched in their positions.

Consider the plight of a small-town community facing the onslaught of woke ideology. The local high school decides to overhaul its curriculum to include a mandatory course on social justice, complete with discussions on privilege, systemic racism, and gender fluidity. The intention is noble, but the execution is clumsy. Parents, accustomed to a more traditional education, are outraged.

They see this as an indoctrination of their children, an assault on their values. The school board meetings become arenas of fierce debate, with neither side willing to budge.

The urban-rural divide is another flashpoint in the cultural wars. In cosmopolitan cities, woke ideology often finds fertile ground, embraced by a populace that prides itself on being progressive and open-minded. But venture into the heartland, and the reception

is far frostier. Here, the language of wokeness is foreign, its concepts alien. The rural communities feel misunderstood and marginalized, their way of life under threat from a movement that seems to devalue everything they hold dear.

The result is a deepening chasm, with each side viewing the other through a lens of suspicion and hostility.

The media, that ever-reliable purveyor of sensationalism, plays a crucial role in exacerbating these divides. News outlets, driven by the insatiable hunger for clicks and ratings, amplify the most extreme voices and the most contentious issues. The nuanced middle ground is lost in the cacophony of outrage and indignation.

Social media platforms, with their algorithms designed to maximize engagement, create echo chambers where users are fed a steady diet of content that

reinforces their existing beliefs. The more sensational and polarizing the content, the better it performs, and the deeper the divisions grow.

Consider the case of a viral tweet that sparks a nationwide debate. A high-profile celebrity makes a controversial statement about gender identity, and within hours, the internet is ablaze with hot takes and fierce arguments. The story is picked up by major news outlets, each adding their spin and further inflaming passions. The public discourse devolves into a shouting match, with little room for reasoned debate or mutual understanding. The tweet, limited in the beginning to a mere 280 characters, becomes a symbol of the cultural rift that wokeness has wrought. These tweets can easily be considered memes in many circumstances.

The impact of wokeness on academia cannot be overstated. Universities, once bastions of

free thought and intellectual diversity, have become hotbeds of ideological conformity.

The pressure to conform to woke standards is immense, stifling dissent and marginalizing those who dare to challenge the prevailing orthodoxy. Professors and students alike navigate a minefield of political correctness, wary of saying anything that might be deemed offensive or problematic. The result is an environment where intellectual exploration is constrained, and critical thinking is often sacrificed at the altar of ideological purity.

In this charged atmosphere, strategies for bridging the cultural divide are both necessary and challenging. One potential approach is to foster spaces for genuine dialogue, where individuals from different backgrounds and perspectives can come together to share their experiences and learn from one another. These conversations, conducted with respect and an open mind, can help to break down the barriers of

misunderstanding and mistrust. Community forums, town hall meetings, and online discussion groups can all serve as platforms for these crucial exchanges.

Education also has a pivotal role to play in healing the rifts caused by wokeness. Schools and universities must strive to teach not just the content of woke ideology but also the skills of critical thinking and respectful debate. Students should be encouraged to question and challenge ideas, including those of wokeness, in a safe and supportive environment.

This approach fosters intellectual resilience and prepares students to engage with the complexities of the real world, rather than retreating into ideological silos.

Media literacy is another essential tool in combating the divisive effects of wokeness. By teaching individuals to critically evaluate the news and social media content they

consume, we can help them to recognize bias and avoid falling into echo chambers. This involves not just identifying unreliable sources but also understanding how algorithms shape our online experiences. Armed with this knowledge, individuals can make more informed choices about the information they consume and the discussions they engage in.

Leadership at all levels, from local community leaders to national politicians, has a critical role in bridging the cultural divide. Leaders must model the values of empathy, respect, and open-mindedness, demonstrating a willingness to engage with those who hold different views. This requires a commitment to dialogue and compromise, rather than pandering to the extremes of the political spectrum.

By fostering a culture of inclusivity and mutual respect, leaders can help to heal the wounds of division and build a more cohesive society.

The business community also has a role to play in addressing the cultural divide. Companies can promote diversity and inclusion in their hiring practices and workplace policies, but they must do so in a way that is genuine and substantive, rather than performative. This means creating environments where all employees feel valued and respected, regardless of their background or beliefs. Hosting a culture of respect and inclusivity, businesses can help to bridge the divides within their own organizations and set an example for the broader society.

Humor, often the first casualty of wokeness, can be a powerful tool in bridging cultural divides. Laughter has a unique ability to bring people together, to defuse tension, and to foster a sense of shared humanity. Comedians and satirists who can skillfully navigate the minefield of political correctness have a vital role in challenging the excesses of wokeness and reminding us

of our common ground. Just by using humor to highlight the absurdities and contradictions of woke culture, they can open up space for critical reflection and dialogue.

Art and culture, too, have a role to play in healing the rifts caused by wokeness. Artists, writers, and filmmakers can use their platforms to tell stories that reflect the diversity of human experience, that challenge simplistic narratives and encourage empathy and understanding.

Creating works that engage with the complexities of identity and culture, they can help to foster a more nuanced and inclusive conversation. Art has the power to transcend ideological divides and to touch the deeper currents of our shared humanity.

The path to ending the divisive effects of wokeness is not easy, but it is essential. We must be fostering genuine dialogue,

promoting critical thinking and media literacy, modeling inclusive leadership, and leveraging the power of humor and art, we can begin to bridge the cultural divides that wokeness has exacerbated.

This requires a commitment to empathy, respect, and open-mindedness, as well as a willingness to engage with those who hold different views. By working together, we can create a more inclusive and cohesive society, where the richness of our diversity is celebrated rather than weaponized.

The stakes are high, but the potential rewards are immense. By addressing the cultural rifts created by wokeness, we can build a society that is more resilient, more innovative, and more just.

This is not just a challenge for those on the front lines of the cultural wars, but for all of us. It requires a collective effort, a commitment to listening and learning, and a

willingness to step outside our comfort zones. But if we can rise to this challenge, we can create a future where the values of inclusivity and diversity are truly realized, not as slogans or marketing strategies, but as lived realities.

The cultural divide wrought by wokeness is both a challenge and an opportunity. It is a challenge because it has created deep and enduring rifts within our society. But it is also an opportunity because it has brought to the surface issues and concerns that need to be addressed.

We must remember engaging with these issues in a thoughtful and constructive way, it is possible to build a society that is more inclusive, more equitable, and more cohesive. This requires a commitment to dialogue, a willingness to listen and learn, and a determination to bridge the divides that separate us.

The process of bridging the cultural divide must begin with a recognition of the shared humanity that connects us all. Despite our differences, we all have common aspirations and values that can serve as the foundation for a more inclusive society.

Focusing on these commonalities and building on them, we can create a sense of unity and solidarity that transcends ideological divides. This requires a shift in mindset, from seeing each other as adversaries to seeing each other as partners in the collective effort to build a better society.

One potential avenue for bridging the cultural divide is through community-building initiatives that bring people together from diverse backgrounds. This is partly why the Chuch of Crypto was created but these initiatives can take many forms, from neighborhood projects and cultural exchanges to sports and recreational activities. Creating opportunities for people to interact and engage with each other in

positive and meaningful ways, we can build the social capital and trust that are essential for a cohesive society.

These initiatives can also help to break down stereotypes and prejudices, fostering a greater understanding and appreciation of our shared humanity.

Another important strategy is to promote inclusive and equitable policies that address the root causes of division and inequality. This involves not just addressing the symptoms of the problem, but tackling the underlying issues that create and perpetuate cultural divides.

This means promoting economic and social policies that ensure everyone has access to the opportunities and resources they need to thrive. It also means addressing systemic issues such as racism, sexism, and other forms of discrimination that create barriers to inclusion and equity.

The role of education in bridging the cultural divide cannot be overstated. Schools and universities have a critical role in shaping the values and attitudes of the next generation. Promoting inclusive and equitable education that values diversity and encourages critical thinking, we can help to create a more inclusive and cohesive society. This involves not just teaching about the issues, but also creating a learning environment that reflects and respects diversity. It also means providing opportunities for students to engage with different perspectives and experiences, fostering a sense of empathy and understanding.

The media also has a crucial role to play in bridging the cultural divide. By providing balanced and accurate coverage of issues and events, the media can help to promote a more informed and nuanced understanding of the issues. This involves not just reporting the facts, but also providing context and analysis that helps to explain the complexities of the issues. It also means

giving voice to diverse perspectives and experiences, ensuring that all voices are heard and represented. By doing so, the media can help to foster a more inclusive and informed public discourse.

Finally, the role of individual action in bridging the cultural divide cannot be overlooked. Each of us has a responsibility to engage with the issues and to promote inclusivity and equity in our own lives. This involves not just talking about the issues, but also taking action to address them. It means challenging our own biases and prejudices, and being open to learning from others. It also means standing up for what is right, even when it is difficult or unpopular. By taking individual action, we can collectively make a difference and build a more inclusive and cohesive society.

The cultural divide created by wokeness is a significant challenge, but it is also an opportunity. By engaging with the issues in a thoughtful and constructive way, we can

build a society that is more inclusive, equitable, and cohesive. This requires a collective effort, a commitment to dialogue and learning, and a willingness to take action. By working together, we can bridge the divides that separate us and create a future where the values of inclusivity and diversity are truly realized. This is not just a challenge for today, but a promise for tomorrow, and it is up to all of us to make it a reality.

Chapter 7: The Erosion of Meritocracy

The concept of meritocracy was once the gleaming pinnacle of fairness, the American Dream's most tantalizing promise. It was the idea that anyone, regardless of their background, could rise to the top through talent, hard work, and sheer determination.

But in today's world, this bedrock principle is under siege. Wokeness, that cunning imposter, has infiltrated the sanctum of meritocracy, replacing it with a labyrinthine system of identity politics. The result is an erosion of the very foundations that once upheld the idea of merit-based success.

Picture, if you will, the boardroom of a major corporation. Once, it was a battlefield where only the sharpest minds and the most innovative thinkers could hope to thrive.

Now, it's more like a social experiment, where hiring decisions are made not by résumés and performance metrics, but by checkboxes on a diversity form. The goal has shifted from assembling the best team possible to creating a tableau of social justice, where representation trumps competence, and the appearance of fairness overrides the reality of merit.

The shift from meritocracy to identity politics began innocuously enough. Diversity and inclusion initiatives were introduced to level the playing field, to ensure that everyone had an equal shot at success. But somewhere along the line, the pendulum swung too far.

Efforts to promote fairness morphed into a mandate for equity, where the outcomes had to be equal, regardless of the input. This new paradigm demanded that individuals be evaluated not on their skills and achievements, but on their demographic characteristics.

The merit-based system, once a bastion of opportunity, was transformed into a minefield of quotas and tokenism.

Consider the plight of a young professional in the tech industry, one of the last remaining bastions of pure meritocracy—or so it was thought. This individual, let's call them Alex, has spent years honing their skills, sacrificing weekends and social life to master their craft. But when it comes time for promotion, Alex finds themselves passed over in favor of a less qualified candidate who fits the desired diversity profile.

The message is clear: merit is secondary to identity. The frustration and disillusionment that follow are not just personal grievances but a reflection of a systemic shift that devalues individual achievement in favor of collective identity.

This new approach to hiring and promotion isn't just a corporate phenomenon; it's also

permeating the world of academia. Universities, once hallowed halls of learning and intellectual rigor, are increasingly prioritizing diversity over merit.

Admissions processes have become battlegrounds where SAT scores and GPAs are weighed against racial and gender quotas. The focus has shifted from rewarding the most capable students to ensuring a demographically balanced student body. The result is a dilution of academic standards and a growing sense of resentment among those who feel they are being judged not for their intellect but for their identity.

The consequences of this shift are far-reaching. In the corporate world, the erosion of meritocracy leads to a decline in productivity and innovation. When hiring and promotion decisions are based on identity rather than ability, the best and brightest are often sidelined, and the overall quality of work suffers. This, in turn,

impacts the company's bottom line and its ability to compete in the global marketplace.

In academia, the devaluation of merit undermines the very purpose of education, which is to foster intellectual growth and prepare students for the challenges of the real world.

One of the most insidious aspects of the erosion of meritocracy is the impact it has on the individuals who are supposed to benefit from these diversity initiatives. The intention behind these policies is to provide opportunities for underrepresented groups, but the reality is often more complicated.

When individuals are hired or promoted based on their identity rather than their abilities, they may find themselves in roles for which they are unprepared. This can lead to a sense of inadequacy and impostor syndrome, as well as resentment from

colleagues who feel that merit has been sidelined.

So, how do we address this erosion of meritocracy? How do we restore a system that rewards talent and hard work while still promoting fairness and inclusion?

The first step is to recognize that meritocracy and diversity are not mutually exclusive. It is possible to create a system that values both, but it requires a commitment to fairness and transparency. This means implementing policies that promote diversity without compromising on standards of excellence. It also means being honest about the trade-offs and challenges involved in balancing these goals.

One potential solution is to redefine the criteria for merit. Rather than focusing solely on traditional measures of achievement, such as test scores and résumés, we can develop more holistic evaluations that take into account a range of

factors, including life experiences, leadership potential, and problem-solving skills.

This approach can help to identify individuals who have the potential to excel but may not have had the same opportunities as others. It also ensures that merit is still the primary criterion for success, while recognizing the value of diversity.

Another important strategy is to create pathways for talent development that are accessible to all. This means investing in education and training programs that provide individuals from diverse backgrounds with the skills and opportunities they need to succeed. It also means creating mentorship and support networks that help individuals navigate the challenges of their careers.

By leveling the playing field at the start, we can ensure that everyone has a fair shot at

success, without resorting to quotas or tokenism.

Companies need to be clear about their hiring and promotion criteria and ensure that these processes are fair and objective. This means implementing blind recruitment practices, where possible, and providing training to reduce unconscious bias. It also means holding managers accountable for their decisions and ensuring that they are based on merit rather than identity.

Academia, too, must recommit to the principles of meritocracy. This means reevaluating admissions processes to ensure that they are fair and transparent, and that they prioritize academic excellence. It also means providing support for students from diverse backgrounds to help them succeed once they are admitted. This can include mentorship programs, tutoring, and other resources that help to level the playing field without compromising on standards.

Another key aspect of restoring meritocracy is fostering a culture that values diversity of thought. In both the corporate and academic worlds, there is a growing trend towards ideological conformity, where dissenting views are not just discouraged but actively silenced. This stifles innovation and critical thinking, as individuals are afraid to challenge the status quo. By promoting a culture of open dialogue and intellectual diversity, we can create environments where individuals are free to express their ideas and where the best ideas can rise to the top.

Humor, again, can be a powerful tool in this battle. We must use memes to promote our message of ending wokeness. Satire and parody can highlight the absurdities of the current system and challenge the dogmas of wokeness. By using humor to critique the erosion of meritocracy, we can open up space for a more nuanced and balanced conversation.

Meme Masters, Comedians and satirists who can skillfully navigate the complexities of these issues can help to shift public perception and foster a more critical and reflective approach to diversity and inclusion.

The role of leadership in this effort cannot be overstated. Leaders in both the corporate and academic worlds must set the tone for their organizations and model the values of meritocracy and inclusivity. This means being willing to make difficult decisions and to stand up for the principles of fairness and excellence. It also means being open to feedback and willing to learn from mistakes.

Demonstrating a commitment to these values, leaders can inspire others to follow suit and create a ripple effect throughout their organizations.

Public policy also has a role to play in restoring meritocracy. Governments can

promote policies that support education and training programs, provide incentives for companies to adopt fair hiring practices, and create regulations that ensure transparency and accountability.

When we are creating a policy framework that supports meritocracy and inclusivity, we can create a more level playing field and promote social mobility.

At the end of the day, restoring meritocracy requires a collective effort. It requires a commitment from individuals, organizations, and society as a whole to value talent and hard work above all else. It requires a willingness to engage in difficult conversations and to challenge the status quo. It also requires a recognition that diversity and meritocracy are not mutually exclusive, but can and should coexist.

Working together, we can create a system that is fair, inclusive, and truly meritocratic.

The erosion of meritocracy is a complex and multifaceted issue, but it is not insurmountable. By recognizing the value of merit and the importance of diversity, and by implementing policies and practices that promote both, we can restore a system that rewards talent and hard work while still promoting fairness and inclusion.

This requires a commitment to transparency, accountability, and open dialogue, as well as a willingness to challenge the dogmas of wokeness. By doing so, we can create a society that is more equitable, more innovative, and more just.

To end the erosion of meritocracy, we must also address the cultural narratives that underpin the current system. The idea that identity should trump merit is rooted in a broader cultural shift towards victimhood and entitlement. This narrative is perpetuated by media, academia, and even

some corporate leaders, and it creates a sense of resentment and division.

Challenging this narrative and promoting a culture of resilience, personal responsibility, and excellence, we can help to shift public perception and restore the value of merit.

One way to do this is through education and public awareness campaigns that highlight the importance of meritocracy and the benefits of a fair and inclusive system. These campaigns can use a variety of media, including social media, television, and print, to reach a broad audience and to challenge the prevailing narrative.

They can also highlight stories of individuals who have succeeded through hard work and talent, and who exemplify the principles of meritocracy.

Another important strategy is to build coalitions of like-minded individuals and organizations who are committed to restoring meritocracy.

These coalitions can work together to advocate for policy changes, to promote best practices, and to challenge the dogmas of wokeness. Working together, these groups can create a powerful force for change and help to shift the cultural and political landscape.

In the workplace, fostering a culture of meritocracy requires a commitment to continuous improvement and learning. This means providing employees with opportunities for professional development and growth, and creating a culture of feedback and accountability.

It also means recognizing and rewarding excellence, and creating pathways for talent to rise to the top. By doing so, companies can create a more motivated and engaged

workforce, and drive innovation and productivity.

Mentorship and sponsorship programs again are very important tools for promoting meritocracy and diversity. By providing individuals from diverse backgrounds with the support and guidance they need to succeed, these programs can help to level the playing field and promote social mobility.

Mentors and sponsors can provide valuable insights, advice, and opportunities, and help to create a more inclusive and supportive work environment.

Restoring meritocracy requires a collective effort. It requires a commitment from individuals, organizations, and society as a whole to value talent and hard work above all else. It requires a willingness to engage in difficult conversations and to challenge the status quo. It also requires a recognition

that diversity and meritocracy are not mutually exclusive, but can and should coexist. Together, we can create a system that is fair, inclusive, and truly meritocratic.

The erosion of meritocracy is a complex and multifaceted issue, but it is not insurmountable. By recognizing the value of merit and the importance of diversity, and by implementing policies and practices that promote both, we can restore a system that rewards talent and hard work while still promoting fairness and inclusion.

Clearly this requires a commitment to transparency, accountability, and open dialogue, as well as a willingness to challenge the dogmas of wokeness.

The erosion of meritocracy is one of the most significant challenges of our time. It undermines the principles of fairness and excellence that are essential for a thriving society, and it creates division and

resentment. But by recognizing the value of merit and the importance of diversity, and by implementing policies and practices that promote both, we can restore a system that is fair, inclusive, and truly meritocratic.

With collective effort, a commitment to transparency and accountability, and a willingness to challenge the prevailing narrative we can create a society that is more equitable, more innovative, and more fair.

Chapter 8: The Legal Landscape

The legal arena, that last bastion of civilization's grand order, has not been spared from the creeping tendrils of wokeness. Once a fortress of rationality and precedent, it now finds itself increasingly influenced by the shifting sands of social justice and identity politics.

The judiciary and legislative bodies are under siege, their hallowed halls echoing with the fervent cries for equity, representation, and reparations. As we dissect this intricate tapestry of legal evolution under the banner of wokeness, we will uncover the profound changes in laws and regulations and their seismic impact on individual rights and freedoms.

Imagine, if you will, the courtroom—a place where justice is supposed to be blind, impartial, and unwavering. Now picture this

noble setting infiltrated by the colorful but chaotic circus of woke ideology.

Judges and juries no longer merely consider the facts of a case and the letter of the law; they are now influenced by the broader societal mandate to correct perceived historical injustices and systemic inequalities. The scales of justice are tipping not based on evidence and reason, but on identity and ideology.

Consider the changes in anti-discrimination laws. Initially crafted to ensure equal treatment and opportunity, these laws are increasingly being expanded and interpreted through a woke lens. Concepts such as "microaggressions" and "implicit bias" are becoming legal battlegrounds. Employers and educational institutions are now required to navigate a minefield of regulations designed to eliminate even the most subjective and intangible forms of discrimination.

This shift has led to a proliferation of lawsuits and compliance mandates that often prioritize identity over intent and substance.

Take the case of an employee who files a complaint about a perceived microaggression—a comment or action that, while innocuous to most, is interpreted as offensive by the individual. The legal machinery swings into action, conducting investigations and imposing sanctions.

The burden of proof is often secondary to the need to demonstrate a commitment to diversity and inclusion. The chilling effect on free speech and open dialogue is palpable, as individuals self-censor to avoid potential legal repercussions.

The education sector has been particularly affected by these legal shifts. Title IX, a law originally intended to prevent sex

discrimination in federally funded education programs, has been reinterpreted to address a wide range of issues related to gender identity and sexual orientation.

Schools and universities are now required to adopt policies and practices that align with woke ideologies, often at the expense of due process and free expression. The rise of campus tribunals adjudicating cases of sexual misconduct and discrimination has led to contentious debates about the balance between protecting victims and ensuring fair treatment for the accused.

Consider the plight of a student accused of sexual harassment under these expanded definitions. The campus tribunal process, designed to be more inclusive and sensitive to victims, often lacks the procedural safeguards found in traditional legal settings.

The accused may find themselves facing severe consequences based on

preponderance of evidence standards and subjective interpretations of behavior. The erosion of due process in these settings highlights the tension between the goals of social justice and the principles of fairness and justice that underpin our legal system.

Companies now implement extensive diversity and inclusion training programs, not merely as good practice but as a legal shield against potential litigation. These programs, while well-intentioned, often promote a narrow interpretation of diversity that prioritizes certain identities over others, creating an environment where meritocracy is overshadowed by identity politics.

The resulting legal landscape is one where compliance trumps innovation and risk-taking is stifled by the fear of legal repercussions.

One of the most contentious areas of woke legal influence is the realm of hate speech

and censorship. Laws designed to combat hate speech are increasingly being used to silence dissenting opinions and stifle free expression. It's legal to burn a flag but a hate crime to do a burnout on a stupid pride sidewalk. The definition of hate speech has expanded to include not just overtly offensive language but also any speech that can be interpreted as harmful or marginalizing to certain groups.

This broad and subjective interpretation poses significant challenges to the principle of free speech, a cornerstone of democratic societies.

Consider the case of a social media user who posts a controversial opinion on a sensitive topic. Under the broad definitions of hate speech, this user could face legal action, platform bans, and social ostracism. The chilling effect on open discourse is evident, as individuals become increasingly wary of expressing their views for fear of legal and social repercussions.

The balance between protecting individuals from harm and preserving the right to free speech is a delicate one, and the current trajectory threatens to tip the scales in favor of censorship.

In the political arena, woke ideology has influenced the legislative process, leading to the introduction of laws and policies aimed at promoting social justice and equity. These laws often seek to address historical injustices and systemic inequalities through affirmative action, reparations, and other redistributive measures.

While these initiatives are rooted in a desire for fairness, they also raise complex legal and ethical questions about the role of government in redressing past wrongs and the impact on individual rights and freedoms.

Consider the debates surrounding affirmative action policies in education and

employment. These policies, designed to increase representation of underrepresented groups, often involve setting quotas or preferences based on race, gender, or other identity markers. The legal challenges to these policies highlight the tension between the goals of diversity and the principles of equal treatment and non-discrimination.

Critics argue that affirmative action undermines meritocracy and creates new forms of discrimination, while proponents contend that it is necessary to level the playing field and address historical injustices.

The legal landscape is further complicated by the rise of reparations movements, which seek compensation for historical injustices such as slavery, colonization, and systemic racism. These movements have gained traction in various jurisdictions, leading to proposals for financial compensation, land restitution, and other forms of redress. The legal implications of such measures are

profound, as they involve complex questions of liability, compensation, and the definition of justice.

The impact on social cohesion and the potential for new divisions and conflicts must also be considered.

To address the legal implications of wokeness and restore a balance between social justice and individual rights, several strategies can be considered. First, there must be a commitment to clarity and precision in the drafting and interpretation of laws and regulations. Vague and broad definitions of concepts such as discrimination, hate speech, and microaggressions create legal uncertainty and open the door to abuse. Clear and precise legal standards are essential to ensure fairness and protect individual rights.

Second, due process and procedural safeguards must be upheld in all legal and

quasi-legal proceedings. Whether in the context of campus tribunals, workplace investigations, or social media moderation, individuals must be afforded the right to a fair hearing and the opportunity to defend themselves against accusations. This includes the presumption of innocence, the right to counsel, and the requirement for evidence-based decision-making. Upholding these principles is essential to maintain public trust in the legal system and ensure justice for all.

Third, the balance between protecting individuals from harm and preserving free speech must be carefully calibrated. Laws and policies designed to combat hate speech and discrimination must be narrowly tailored to address genuine threats without stifling open discourse and debate. The principle of free speech is foundational to democratic societies, and any limitations on this right must be justified by compelling and narrowly defined interests.

Fourth, diversity and inclusion initiatives must be designed to promote genuine equity without undermining meritocracy and individual rights. This involves moving beyond tokenistic measures and developing holistic approaches that address the root causes of inequality. Education and training programs should focus on building skills and competencies, rather than simply promoting identity-based quotas.

Fifth, public awareness and education are crucial to fostering a more informed and balanced approach to social justice and legal reform. This involves promoting media literacy, critical thinking, and an understanding of the principles of justice and equity. By equipping individuals with the knowledge and skills to engage with these complex issues, we can create a more informed and engaged citizenry that is capable of navigating the challenges of the modern legal landscape.

Finally, leadership at all levels—political, corporate, and community—must

demonstrate a commitment to fairness, transparency, and accountability. Leaders must be willing to engage in difficult conversations, challenge prevailing narratives, and make decisions based on evidence and principles rather than ideology. By setting an example of integrity and courage, leaders can inspire others to follow suit and create a culture of justice and equity.

The legal landscape under the influence of wokeness is a complex and evolving terrain, marked by significant challenges and opportunities. By recognizing the impact of woke ideology on laws and regulations, and by implementing strategies to address these challenges, we can work towards a more balanced and just legal system. This requires a collective effort, a commitment to principles, and a willingness to engage with difficult and contentious issues. By doing so, we can ensure that the legal system serves the interests of all individuals and upholds the values of justice, fairness, and equality.

The legal implications of wokeness are profound and far-reaching, affecting every aspect of society from the workplace to the courtroom to the legislature. The erosion of meritocracy, the challenges to free speech, and the complexities of affirmative action and reparations all highlight the need for a thoughtful and balanced approach to legal reform. Simply upholding the principles of clarity, due process, free speech, and meritocracy, and by fostering a culture of inclusivity and respect, we can create a legal landscape that is both fair and just.

This requires a collective effort, a commitment to principles, and a willingness to engage with difficult and contentious issues. By doing so, we can ensure that the legal system serves the interests of all individuals and upholds the values of justice, fairness, and equality.

As we navigate the legal landscape shaped by wokeness, it is essential to remain vigilant and proactive in protecting individual rights and freedoms. This involves not only addressing the immediate challenges but also anticipating future developments and preparing for the evolving legal environment. When we are fostering a culture of continuous learning and adaptation, we can ensure that the legal system remains responsive to the needs of society and capable of upholding justice in the face of changing social and political dynamics.

One of the key areas to watch is the intersection of technology and the law. The rapid advancement of digital technologies and the increasing influence of social media platforms have created new challenges for the legal system. Issues such as data privacy, algorithmic bias, and online harassment require innovative legal approaches and a deep understanding of the technological landscape. As we address these challenges, it is crucial to ensure that the principles of

fairness, transparency, and accountability are upheld in the digital realm.

Another important consideration is the global dimension of the legal landscape. The influence of wokeness is not confined to any single country but is a global phenomenon that affects legal systems around the world. International cooperation and dialogue are essential to address the transnational aspects of social justice and legal reform. By sharing best practices and learning from the experiences of other countries, we can develop more effective and equitable legal frameworks that address the challenges of wokeness in a globalized world.

The role of civil society and grassroots movements is also critical in shaping the legal landscape. Activists, advocacy groups, and community organizations play a vital role in raising awareness, mobilizing public support, and holding institutions accountable. By fostering collaboration and dialogue between civil society and legal

institutions, we can create a more inclusive and participatory approach to legal reform. This involves not only addressing the symptoms of inequality but also tackling the root causes and structural factors that perpetuate injustice.

The journey to ending woke culture and restoring a balanced legal landscape is a complex and multifaceted endeavor. It requires a commitment to principles, a willingness to engage with difficult issues, and a dedication to continuous learning and adaptation. By fostering a culture of fairness, transparency, and accountability, and by promoting inclusivity and respect, we can create a legal system that upholds the values of justice and equality for all individuals.

In the end, the legal landscape shaped by wokeness presents both challenges and opportunities. By addressing these challenges with thoughtfulness and integrity, we can work towards a more just and

equitable society. This requires a collective effort, a commitment to principles, and a willingness to engage with difficult and contentious issues. By doing so, we can ensure that the legal system serves the interests of all individuals and upholds the values of justice, fairness, and equality.

Chapter 9: Science and Objectivity Under Siege

In the pantheon of human achievement, science has always been the bedrock of progress, the unyielding beacon of truth guiding us through the murky waters of ignorance. But in the era of wokeness, even this sacred realm has not been spared. Wokeness, with its insidious tendrils, has crept into the hallowed halls of scientific inquiry, casting a shadow over objectivity and empirical evidence. The once-clear waters of scientific discourse are now muddied with ideological fervor, where facts are often sacrificed on the altar of social justice.

Imagine the scientific community as a vast, intricate clockwork, each cog and gear meticulously crafted to advance our understanding of the universe. Now picture a group of well-meaning but misguided activists jamming wrenches into the machinery, insisting that the gears turn not

in accordance with the laws of physics, but with the dictates of woke ideology.

The result is chaos and dysfunction, where the pursuit of knowledge is hindered by the demands of ideological purity.

One of the most glaring examples of this tension is the controversy surrounding research on human biology and genetics. The study of human differences, once a legitimate and important field of inquiry, has become a minefield of political correctness.

Researchers who dare to explore genetic variations between populations or the biological basis of sex differences are often branded as bigots and ostracized by their peers. Grants are denied, papers are retracted, and careers are ruined, all in the name of wokeness.

Consider the case of a prominent geneticist who published a study on the genetic basis of intelligence. The research, grounded in rigorous methodology and peer-reviewed, suggested that there are genetic factors that contribute to cognitive abilities. The woke backlash was swift and brutal. Accusations of eugenics and racism were hurled at the scientist, and calls for retraction and apology echoed through the academic community. The focus shifted from the scientific merits of the research to the perceived moral failings of the researcher.

The field of medicine is not immune to this ideological encroachment. The rigorous process of clinical trials and evidence-based practice is increasingly being challenged by woke activists who prioritize identity politics over patient outcomes.

There is a growing demand for research funding to be allocated based on the diversity of the research team rather than the potential impact of the study. This has led to

a dilution of research quality and a diversion of resources from critical areas of medical inquiry.

Take, for example, the controversy surrounding the treatment of gender dysphoria in adolescents. The medical community is deeply divided on the best approach, with some advocating for puberty blockers and hormone therapy, while others caution against these interventions due to the lack of long-term data. Woke activists, however, have made it clear that any hesitation or dissent is unacceptable. Doctors and researchers who express concerns about the risks and unknowns are labeled as transphobic and subjected to campaigns of harassment and professional censure. The result is a chilling effect on open scientific debate and a potential risk to patient safety.

The environmental sciences, too, have felt the squeeze of woke ideology. Climate change research, once a unifying call to

action based on robust scientific consensus, has been co-opted by ideological agendas.

While the urgency of addressing climate change is mostly undeniable, the woke narrative often conflates environmental stewardship with broader social justice issues, muddying the waters of policy and action. This conflation can divert attention from practical, science-based solutions to climate change in favor of more nebulous and ideologically driven initiatives.

Consider the debate over renewable energy policies. The push for clean energy is essential, but woke activists often insist that these initiatives must also address racial and economic disparities, sometimes at the expense of efficiency and feasibility.

The result is a set of policies that may be less effective in combating climate change and more focused on achieving ideological goals. This intersectional approach, while

well-intentioned, can undermine the pragmatic, science-based efforts needed to address the pressing issue of climate change.

The academic community, once a bastion of free inquiry, is increasingly becoming a stronghold of ideological conformity. Departments of social sciences and humanities are particularly affected, where the pursuit of knowledge is often subordinated to the demands of woke orthodoxy.

The pressure to conform to the prevailing narrative is immense, with researchers and scholars who deviate from the party line facing ostracism, denial of tenure, and even dismissal.

Consider the field of sociology, where the study of social structures and behaviors has been heavily influenced by woke ideology. Researchers who explore topics such as crime, family dynamics, or educational

achievement through lenses that do not align with woke beliefs are often marginalized. The emphasis is on producing research that supports the narrative of systemic oppression and victimhood, rather than on conducting objective and rigorous analysis. The result is a body of work that is ideologically homogeneous and less likely to contribute to meaningful social progress.

The tension between wokeness and scientific objectivity is perhaps most evident in the realm of academic publishing. Journals, once gatekeepers of quality and rigor, are increasingly swayed by the demands of woke activists.

The peer review process, designed to ensure that only the most robust and credible research is published, is often subverted by ideological considerations. Papers that challenge woke orthodoxy face higher hurdles for acceptance, while those that conform to the narrative are fast-tracked.

One striking example is the retraction of published papers due to woke pressure. Consider a study that explores the differences in educational outcomes among different demographic groups. If the findings suggest that cultural or socioeconomic factors play a significant role, the research may be attacked as reinforcing stereotypes or victim-blaming.

The pressure mounts on journal editors to retract the paper, often leading to a capitulation that undermines the integrity of the scientific process.

The role of funding agencies in this ideological shift cannot be overlooked. Research grants are increasingly awarded based on the perceived social impact of the study rather than its scientific merit. Proposals that align with woke priorities, such as those focusing on intersectionality or systemic oppression, are more likely to

receive funding. This creates a perverse incentive for researchers to tailor their work to fit the ideological mold, rather than pursuing questions based on scientific curiosity and societal need.

To address the siege on scientific objectivity, several strategies can be considered. First and foremost, the scientific community must reaffirm its commitment to the principles of empirical evidence and rigorous methodology.

This means standing firm against ideological pressure and upholding the standards of quality and integrity that have long defined scientific inquiry. Institutions and funding agencies must prioritize merit and scientific merit over ideological conformity, ensuring that research is evaluated based on its potential to advance knowledge and address real-world problems.

Second, the academic community must foster an environment that encourages open dialogue and intellectual diversity. This involves creating spaces where researchers can freely explore controversial topics and present dissenting views without fear of retribution.

Universities and research institutions must adopt policies that protect academic freedom and promote a culture of respectful debate. By valuing diverse perspectives and encouraging critical thinking, the academic community can resist the homogenizing influence of woke ideology.

Third, the peer review process must be strengthened to ensure that it remains a rigorous and objective gatekeeper of scientific quality. Journals and editorial boards must resist the pressure to publish research based on its ideological alignment and focus instead on the robustness of the methodology and the validity of the findings.

Transparency in the review process, including the publication of reviewer comments and the criteria for acceptance, can help to maintain the integrity of academic publishing.

Fourth, funding agencies must adopt policies that promote merit-based evaluation of research proposals. This involves developing clear and objective criteria for grant awards, focusing on the scientific merit and potential impact of the proposed research.

By prioritizing quality and innovation over ideological considerations, funding agencies can support a diverse range of research that advances knowledge and addresses societal challenges.

Fifth, the role of science communication is crucial in bridging the gap between scientific research and public understanding. Scientists and researchers must engage with

the broader public to explain the importance of scientific objectivity and the dangers of ideological interference. If we are promoting science literacy and fostering a culture of critical thinking, we can empower individuals to evaluate scientific claims based on evidence and reason, rather than ideological alignment.

By highlighting the absurdities and contradictions of woke-driven policies and practices we can expose the flaws in the ideological assault on scientific objectivity and encourage a more balanced and rational approach to scientific inquiry.

Leadership again within the scientific community is also essential in this effort. Prominent scientists, researchers, and academic leaders must take a stand against the erosion of meritocracy and objectivity. By speaking out against ideological interference and advocating for the principles of rigorous inquiry, they can inspire others to follow suit.

Leadership that embodies the values of integrity, courage, and intellectual curiosity can help to steer the scientific community back toward its foundational principles.

Public policy also has a role to play in protecting scientific objectivity. Governments and regulatory bodies must ensure that research funding is allocated based on merit and scientific impact rather than ideological alignment.

Policies that promote transparency, accountability, and the protection of academic freedom can help to create a legal framework that supports rigorous and objective scientific inquiry. By enshrining these principles in law, we can safeguard the integrity of the scientific enterprise.

The tension between wokeness and scientific objectivity represents a significant

challenge to the pursuit of knowledge and progress. The encroachment of ideological considerations into the realm of science undermines the principles of empirical evidence and rigorous methodology that are essential for scientific inquiry. By reaffirming our commitment to these principles, fostering an environment of open dialogue and intellectual diversity, strengthening the peer review process, promoting merit-based evaluation of research proposals, and engaging in effective science communication, we can resist the ideological assault on science and ensure that it remains a beacon of truth and progress.

The siege on scientific objectivity is not just a battle for the hearts and minds of the scientific community, but a broader struggle for the values of reason, evidence, and critical thinking in society.

As we are addressing this challenge with thoughtfulness, integrity, and a commitment

to the principles of scientific inquiry, we can create a future where knowledge and progress are guided by evidence and reason, not by the shifting sands of ideological fervor. This requires a collective effort, a dedication to the principles of science, and a willingness to stand firm against the pressures of wokeness.

Doing so, we can ensure that science continues to illuminate the path to a better and more enlightened world.

Chapter 10: The Influence on Arts and Literature

Arts and literature, those untamed bastions of human expression and creativity, have long stood as the mirrors of society, reflecting its hopes, dreams, fears, and follies. Yet, in the current era of wokeness, even these realms have not escaped unscathed. The once free-spirited world of the artist and the writer now finds itself under the watchful eye of the woke ideology, where the creative process is hemmed in by the rigid lines of political correctness.

This chapter explores how wokeness has seeped into the veins of arts and literature, altering themes, prompting censorship, and changing how creative works are received.

Imagine the artistic community as a bustling carnival of color and noise, each artist a vibrant performer with a unique act. Now,

picture the ringmaster of wokeness stepping into the center ring, dictating which acts are acceptable and which must be retired. The carnival loses its spontaneity, its raw, unfiltered energy, becoming instead a carefully curated exhibition of socially approved performances.

The daring high-wire acts are replaced by safe, predictable routines, and the once-boisterous crowd watches with polite, but tepid, applause.

One of the most significant shifts in the artistic landscape is the thematic evolution driven by woke ideology. In the past, artists and writers felt free to explore the full spectrum of human experience, delving into the dark recesses of the psyche, challenging societal norms, and presenting unvarnished truths. Today, the themes that dominate the arts are often those that align with woke principles: social justice, identity politics, and intersectionality.

While these themes are undoubtedly important, their dominance has come at the expense of a broader, more diverse artistic exploration.

Consider the impact on literature. The literary world, once a wild frontier where authors like Hemingway, Orwell, and Kafka roamed free, now resembles a well-manicured garden where only certain plants are allowed to flourish.

Publishers and literary agents, ever attuned to the zeitgeist, favor manuscripts that reflect woke values. Stories that challenge these values or present controversial viewpoints struggle to find a home. The result is a literary landscape that is ideologically homogeneous and less rich in its diversity of thought.

Censorship, both overt and covert, has become a pervasive force in the arts. The pressure to conform to woke standards often leads to self-censorship, where artists and writers preemptively alter their work to avoid backlash.

This insidious form of censorship is perhaps more damaging than any government decree, as it stifles creativity at its source. The fear of being labeled as insensitive or problematic hangs over the creative process like a dark cloud, dampening the vibrant sparks of innovation and originality.

Take the example of a playwright who pens a controversial drama exploring the complexities of racial tension in a way that doesn't conform to the woke narrative. The script, while provocative and thought-provoking, is met with resistance from theaters afraid of alienating their woke audiences. The play is never produced, and a potentially valuable contribution to the discourse on race is lost. This scenario plays

out across all artistic mediums, from film and television to visual arts and music.

The reception of creative works has also been profoundly affected by wokeness. Critics and audiences alike evaluate art not just on its aesthetic merits but on its alignment with woke values. A film, book, or painting that fails to check the right ideological boxes can expect a frosty reception, regardless of its artistic quality. This shift has created a cultural environment where artists feel compelled to signal their virtue through their work, often at the expense of authenticity and artistic integrity.

Consider the film industry, where the push for woke representation has led to the rise of what some call "tokenism." Filmmakers, under pressure to reflect diversity, often resort to superficial inclusivity—casting characters of different races, genders, and sexual orientations without fully developing their roles or stories.

The result is a hollow form of representation that satisfies the woke criteria but fails to achieve genuine inclusivity. This approach undermines the potential for rich, complex storytelling and leaves audiences feeling pandered to rather than genuinely represented.

The music industry, too, has felt the influence of wokeness. Songs that once pushed boundaries and challenged societal norms now face scrutiny for their content. Lyrics are dissected for potential offenses, and artists are expected to toe the ideological line. This has led to a sanitization of music, where edgy and provocative content is often watered down to avoid controversy. The rebellious spirit that once defined genres like punk, rap, and rock is increasingly replaced by a more cautious and calculated approach.

The visual arts have not been spared either. Art galleries and museums, traditionally spaces of radical experimentation and avant-garde expression, now often prioritize works that align with woke themes.

Exhibitions are curated to reflect a commitment to diversity and social justice, often at the expense of artistic merit.

While it is important to showcase a diverse range of artists, the emphasis on ideological alignment can lead to a form of cultural gatekeeping that excludes unconventional or challenging perspectives.

To address the encroachment of wokeness into the arts and literature, several strategies can be considered. First and foremost, it is essential to reaffirm the value of artistic freedom and the importance of diverse perspectives. Artists and writers must be encouraged to explore all facets of the human experience, even those that are uncomfortable or controversial. This means creating spaces where creative individuals

can express themselves without fear of censorship or backlash.

One potential approach is to establish independent platforms and venues that champion artistic freedom. These spaces can serve as incubators for innovative and unconventional work, providing artists with the support and resources they need to pursue their creative visions. By fostering a culture of experimentation and risk-taking, these platforms can help to counteract the homogenizing influence of wokeness and promote a more vibrant and diverse artistic landscape.

Another important strategy is to promote critical thinking and media literacy among audiences. By encouraging individuals to engage with art and literature on a deeper level, we can foster a more discerning and open-minded public. This involves teaching audiences to appreciate the nuances and complexities of creative works, rather than evaluating them solely based on their

ideological alignment. By cultivating a culture of critical engagement, we can create an environment where diverse perspectives are valued and celebrated.

The role of critics and reviewers is also crucial in this effort. Critics must be willing to evaluate art based on its artistic merits rather than its adherence to woke values. This requires a commitment to objectivity and a willingness to challenge prevailing narratives. By providing thoughtful and nuanced critiques, critics can help to elevate the discourse around art and literature and promote a more inclusive and open-minded cultural environment.

Education plays a vital role in fostering a culture of artistic freedom and critical engagement. Schools and universities must prioritize the teaching of critical thinking and creative expression, encouraging students to explore diverse perspectives and challenge conventional wisdom. This involves providing a broad and inclusive

curriculum that reflects the full spectrum of human experience, rather than a narrow, ideologically driven narrative. When we are equipping students with the skills and knowledge they need to engage with art and literature on a deeper level, we can foster a new generation of artists and audiences who value creativity and intellectual diversity.

The role of public policy in supporting artistic freedom cannot be overlooked. Governments and funding bodies must ensure that support for the arts is based on merit and artistic quality, rather than ideological alignment. This involves developing clear and transparent criteria for grant awards and funding allocations, focusing on the potential impact and innovation of the proposed work. By promoting a merit-based approach to arts funding, we can create an environment where diverse and unconventional voices are supported and celebrated.

Humor and satire can also play a powerful role in challenging the influence of wokeness in the arts. By using humor to highlight the absurdities and contradictions of woke-driven policies and practices, comedians and satirists can provoke reflection and discussion. Through satire, we can expose the flaws in the ideological assault on artistic freedom and encourage a more balanced and rational approach to the arts. Humor has the unique ability to cut through ideological fervor and reveal the underlying truths, making it an invaluable tool in the fight for artistic freedom.

Leadership within the artistic community is essential in this effort. Prominent artists, writers, and cultural leaders must take a stand against the erosion of artistic freedom and champion the values of creativity and intellectual diversity. By speaking out against censorship and ideological conformity, they can inspire others to follow suit and create a ripple effect throughout the artistic community.

Leadership that embodies the values of integrity, courage, and creative exploration can help to steer the arts back toward their foundational principles.

Public awareness and advocacy are crucial in promoting artistic freedom and challenging the influence of wokeness in the arts. This involves raising awareness about the impact of ideological conformity on the creative process and advocating for policies and practices that support artistic freedom.

Begin mobilizing public support and engaging in advocacy efforts, this is how we can create a cultural environment where diverse perspectives are valued and celebrated. This requires a collective effort, a commitment to the principles of artistic freedom, and a willingness to engage with difficult and contentious issues.

The influence of wokeness on the arts and literature represents a significant challenge

to the principles of creative freedom and intellectual diversity. The encroachment of ideological conformity into the creative process stifles innovation, limits the diversity of thought, and undermines the authenticity of artistic expression.

Through reaffirming the value of artistic freedom, promoting critical thinking and media literacy, supporting independent platforms and venues, and fostering a culture of humor and satire, we can resist the ideological assault on the arts and ensure that creativity remains a vibrant and dynamic force in society.

The path to ending woke culture in the arts and literature is a complex and multifaceted endeavor, requiring a commitment to principles, a dedication to continuous learning and adaptation, and a collective effort to foster a culture of creativity and intellectual diversity. Start standing firm against the pressures of wokeness and championing the values of artistic freedom,

together we can create a future where the arts and literature continue to illuminate the human experience in all its richness and complexity. This requires a collective effort, a dedication to the principles of artistic freedom, and a willingness to stand firm against the pressures of wokeness. By doing so, we can ensure that the arts and literature continue to illuminate the human experience in all its richness and complexity.

Chapter 11: Religion and Wokeness

In the quiet, echoing halls of spiritual sanctuaries where the whispers of ancient prayers once reigned supreme, a new and discordant voice has emerged. Wokeness, with its fervent zeal and uncompromising doctrines, has stormed the gates of religion, attempting to bend millennia-old traditions and beliefs to its will.

The clash between these two powerful forces has created a battleground where sacred texts and social justice slogans are

wielded with equal fervor, leading to a complex and often contentious intersection of faith and ideology.

Imagine, if you will, the grand cathedrals, humble mosques, serene temples, and vibrant synagogues of the world. These are the places where humanity has sought solace, meaning, and connection with the divine for centuries.

Now picture these spaces as arenas where the faithful grapple not only with their spiritual journeys but also with the relentless push of woke ideology. The tension is palpable, the stakes high, and the outcomes unpredictable.

The first ripples of this cultural tsunami appeared innocuously enough. Calls for greater inclusivity and representation within religious communities echoed the broader societal demands for social justice.

Many religious leaders, recognizing the importance of compassion and equality, embraced these changes with open arms. Churches, mosques, temples, and synagogues began to reflect the diversity of their congregations, incorporating new voices and perspectives into their spiritual discourse.

However, as with any powerful movement, the initial goodwill was soon overshadowed by more radical demands. Woke activists, with their uncompromising stance, began to push for changes that struck at the core of religious doctrines and practices. Traditional beliefs and long-held tenets were challenged, not through theological debate, but through the lens of social justice. The result was a deepening rift within religious communities, where congregants found themselves at odds over how to reconcile their faith with the demands of wokeness.

Take, for example, the debates within Christian churches over issues such as gender and sexuality. Many denominations have faced internal conflicts as they grapple with how to approach LGBTQ+ inclusion.

Progressive factions argue for the full acceptance and affirmation of LGBTQ+ individuals, while more conservative members hold fast to traditional interpretations of scripture. The tension between these perspectives has led to schisms, with some congregations splitting entirely over these contentious issues. The debate is not merely theological but deeply personal, as individuals wrestle with their faith and their desire for social justice.

In the Islamic world, the intersection of wokeness and religion presents a different set of challenges. Islamic teachings, with their emphasis on tradition and community, often clash with the individualistic and relativistic tendencies of woke ideology. Issues such as women's rights, LGBTQ+

inclusion, and freedom of expression are flashpoints in this cultural collision.

Rarely Muslim communities have embraced aspects of woke ideology, advocating for greater gender equality and social justice within an Islamic framework. Others, however, view these efforts as a threat to their religious identity and cultural heritage, leading to internal and external conflicts. Islam as a whole is not woke.

Judaism, with its rich tapestry of cultural and religious diversity, is another battleground where wokeness has made its mark. The progressive branches of Judaism have long championed social justice causes, aligning themselves with many of the principles of wokeness. However, this alignment is not without its tensions. Traditional and Orthodox Jewish communities often find themselves at odds with the more progressive elements, particularly on issues such as gender roles and LGBTQ+ inclusion. The resulting

conflicts are deeply felt, as they touch on both religious identity and communal cohesion.

Hinduism and Buddhism, with their diverse traditions and practices, also face challenges from woke ideology. The emphasis on social justice and equality can sometimes conflict with the hierarchical and ritualistic aspects of these religions. Issues such as caste discrimination in Hinduism and gender equality in Buddhism are areas where woke activists have pushed for change. While some religious leaders have embraced these calls for reform, others view them as external impositions that threaten the integrity of their traditions.

To navigate these complex intersections and address the tensions between wokeness and religion, several strategies can be considered. First and foremost, it is essential to foster open and respectful dialogue within religious communities. This means creating spaces where individuals can express their

views and beliefs without fear of retribution or ostracism. By encouraging honest and compassionate conversations, religious communities can find ways to reconcile their faith with the demands of social justice, without compromising on their core values.

One potential approach is to revisit and reinterpret religious texts and traditions in a way that aligns with contemporary values while maintaining theological integrity. Many religious traditions have a rich history of interpretation and adaptation, and this flexibility can be leveraged to address modern issues. By engaging in thoughtful and nuanced theological exploration, religious leaders can find ways to integrate principles of justice and equality into their teachings, without undermining their faith's core tenets.

Education and awareness are also crucial in bridging the gap between wokeness and religion. By promoting a deeper understanding of both religious teachings

and social justice principles, communities can foster greater empathy and cooperation.

This involves providing education on the historical and cultural contexts of religious beliefs, as well as on the goals and motivations of woke activism. By fostering mutual understanding, religious communities can find common ground and work together towards shared goals of justice and equality.

Another important strategy is to promote the values of humility and compassion within religious communities. The teachings of many religious traditions emphasize the importance of loving one's neighbor, showing mercy, and seeking justice.

When we are focusing on these universal values, religious communities can find common cause with woke activists, while also maintaining their distinct religious identity. This approach involves recognizing

the humanity and dignity of all individuals, regardless of their beliefs or backgrounds.

The role of leadership in navigating the intersection of wokeness and religion is critical. Religious leaders must demonstrate a commitment to both their faith and the principles of justice and equality without giving in to work mobs.

This requires courage, wisdom, and a willingness to engage with difficult and contentious issues. By modeling respectful dialogue, open-mindedness, and a commitment to justice, religious leaders can inspire their communities to do the same and eradicate wokeness. Leadership that embodies these values can help to bridge the divides and promote a more inclusive and compassionate religious environment without bending value to woke lunatics.

The intersection of wokeness and religion presents a complex and challenging landscape. The tensions between these powerful forces have created conflicts within religious communities, as they grapple with how to reconcile their faith with the demands of social justice. By fostering open and respectful dialogue, revisiting and reinterpreting religious texts, promoting education and awareness, emphasizing humility and compassion, and leveraging the power of humor and satire, we can address these tensions and find ways to integrate principles of justice and equality into religious teachings and practices without caving into work extremists. The journey to ending woke culture in religion requires a collective effort, a commitment to principles, and a willingness to engage with difficult and contentious issues. Doing so, we can ensure that religious communities continue to be spaces of solace, meaning, and connection, while also promoting justice and equality in society while having a backbone and not giving power to the insane woke mobs.

To further explore how to end woke culture's influence on religion, we must delve deeper into the practical strategies and ideas that can facilitate this process. These strategies must be multifaceted, addressing the various aspects of religious life and community dynamics that are affected by woke ideology.

One practical strategy is to develop and implement educational programs that focus on the intersection of faith and social justice. These programs can be designed to educate religious leaders and congregants about the principles of social justice, while also grounding these principles in the teachings and values of their faith traditions. By providing a theological framework for understanding and addressing social justice issues, these programs can help to bridge the gap between wokeness and religion. This approach involves integrating social justice education into religious curricula, sermons, and study groups, creating a holistic and

comprehensive understanding of these issues and dismissing this insanity that is within.

Another important strategy is to foster interfaith dialogue and collaboration. By bringing together religious leaders and communities from different faith traditions, we can promote mutual understanding and cooperation in addressing social justice issues that matter. Interfaith dialogue provides a platform for sharing perspectives, learning from one another, and finding common ground. Through collaborative initiatives, such as community service projects and advocacy efforts, religious communities can work together to promote justice and equality, while also respecting their distinct beliefs and practices.

Community-building initiatives are also crucial in promoting a balanced approach to social justice within religious communities.

These initiatives can create opportunities for congregants to engage in meaningful and impactful social justice work, while also fostering a sense of unity and solidarity. By organizing events such as volunteer projects, non woke social justice workshops, and community forums, religious communities can provide spaces for individuals to come together, share their experiences, and work towards common goals. These initiatives help to build a strong and supportive community that is committed to both faith and justice while excluding harmful ideologies.

To address the influence of wokeness on religious practices and rituals, it is important to encourage creativity and innovation within religious traditions. This involves exploring new ways of expressing and practicing faith that are inclusive and reflective of contemporary values non woke values, while honoring the core tenets of their religion. Religious leaders and communities can experiment with incorporating diverse cultural elements,

modern interpretations of rituals, and inclusive language into their practices. By embracing creativity and innovation, religious communities can create a dynamic and evolving spiritual experience that resonates with their congregants and addresses the demands of social justice in a basic sence.

Mentorship and support networks play a vital role in navigating the intersection of wokeness and religion. By providing guidance and support to individuals who are grappling with these issues, religious communities can help their members to find a balance between their faith and their commitment to normal social justice. Mentorship programs can pair experienced religious leaders and social justice advocates with individuals seeking to deepen their understanding and engagement with these issues. Support networks, such as discussion groups and counseling services, can offer a safe and supportive space for individuals to explore their beliefs and experiences.

To promote a balanced and inclusive approach to sane social justice within religious communities, it is important to develop clear and transparent policies and guidelines. These policies should outline the community's commitment to justice and equality, while also respecting religious beliefs and practices. It will also be blunt about rejecting extreme woke ideologies. By establishing guidelines for addressing issues such as discrimination, harassment, and inclusion, religious communities can create a supportive and equitable environment for all members. These policies should be developed through a collaborative process, involving input from diverse voices within the community, to ensure that they reflect the needs and values of the entire congregation.

The role of media and communication is also critical in addressing the influence of wokeness on religion. Religious communities must leverage various media

platforms to share their perspectives, educate the public, and promote a balanced approach to social justice. This involves creating content that highlights the intersection of faith and justice, sharing success stories and best practices, and engaging in public discourse on these issues. By using media effectively, religious communities can amplify their message and reach a broader audience, fostering greater understanding and support for their efforts while actively steering them away from the far far lefts vision of hell they wish to bring to earth.

Finally, it is essential to cultivate a culture of continuous learning and growth within religious communities. This involves encouraging individuals to engage in ongoing education and reflection on issues of faith and justice.

Religious leaders can promote a culture of learning by offering educational programs, hosting guest speakers, and providing

resources for further study. By fostering a mindset of curiosity and openness, religious communities can create an environment where individuals feel empowered to explore and grow in their understanding of these complex issues.

The intersection of wokeness and religion presents a challenging but also an opportunity-rich landscape. By implementing practical strategies such as education, interfaith dialogue, community-building initiatives, creativity and innovation, mentorship and support networks, clear policies and guidelines, effective media communication, and a culture of continuous learning, religious communities can navigate these complexities and promote a balanced approach to social justice.

Ending the influence of woke culture on religion requires a collective effort, a commitment to principles, and a willingness to engage with difficult and contentious

issues. By doing so, we can ensure that religious communities continue to be spaces of solace, meaning, and connection, while also promoting justice and equality in society.

This journey is not just about addressing the challenges of the present but also about building a foundation for a more inclusive and compassionate future.

Chapter 12: Family and Personal Relationships

Picture the typical family dinner—a scene as American as apple pie and awkward silences. The table is set, the roast is carved, and the conversation flows, or at least it used to.

In the era of wokeness, these familial gatherings have transformed into ideological minefields where every comment is a potential grenade, primed to explode at the slightest provocation. The once-simple act of sharing a meal has become a delicate dance of diplomacy, where the wrong word can shatter the fragile peace and turn a festive occasion into a battleground of beliefs.

The effects of wokeness on family dynamics are profound, creating generational divides and straining personal relationships. The older generation, raised on a steady diet of

traditional values and unfiltered opinions, often finds itself at odds with the younger, more woke members of the family.

This clash of ideologies can lead to heated arguments, silent treatments, and, in some cases, permanent rifts. The challenge of maintaining harmony in a woke environment is not for the faint of heart; it requires a careful balance of empathy, respect, and strategic avoidance of certain topics.

Consider the case of Thanksgiving dinner, that annual ritual of gratitude and gluttony. The extended family gathers, bringing with them a smorgasbord of perspectives and opinions. Grandpa Joe, with his weathered face and tales of the good old days, sits at one end of the table, while at the other, young Emily, fresh from her first semester at an Ivy League university, is brimming with woke fervor.

As the conversation inevitably turns to politics, the tension becomes palpable. Grandpa Joe's casual remark about the economy is met with Emily's impassioned lecture on systemic inequality. The room falls silent, forks pause mid-air, and everyone braces for the fallout.

Navigating these treacherous waters requires a nuanced approach. The first step is recognizing the generational differences that underpin these conflicts. The older generation, shaped by different historical and cultural contexts, may hold views that seem antiquated or offensive to younger, woke individuals. On the other hand, the younger generation, influenced by contemporary social justice movements, may appear overly sensitive or dogmatic to their elders.

Understanding these differences is crucial in fostering empathy and preventing misunderstandings. With age comes wisdom, it is very possible in 20 years

Emily may agree more with Grandpa than she does with her younger self.

One effective strategy for maintaining family harmony is to establish boundaries and guidelines for discussion. This can involve setting ground rules for conversations, such as avoiding certain contentious topics during family gatherings or agreeing to disagree on specific issues. When we are creating a framework for respectful dialogue, families can prevent arguments from escalating and ensure that everyone feels heard and valued.

It's about finding common ground and recognizing that, despite ideological differences, the bonds of family can transcend political beliefs.

Another important approach is to focus on shared values and experiences. Despite ideological differences, families often have common values and traditions that can serve

as a foundation for connection. Start emphasizing these shared aspects, families can build a sense of unity and mutual respect.

This might involve celebrating family traditions, engaging in collective activities, or simply spending quality time together without the pressure of ideological debates. The goal is to strengthen the familial bonds that transcend political and social differences.

Education and open-mindedness are also critical in navigating the effects of wokeness on family dynamics. Encouraging family members to educate themselves on different perspectives and engage in open-minded dialogue can foster greater understanding and empathy.

This involves listening actively, asking questions, and being willing to challenge one's own assumptions. By creating a

culture of continuous learning and intellectual curiosity, families can navigate ideological differences more effectively and maintain harmonious relationships.

Personal relationships outside the family are not immune to the influence of wokeness. Friendships, romantic relationships, and professional connections can all be affected by ideological differences. The key to maintaining these relationships lies in the same principles of empathy, respect, and open communication. Recognizing that everyone is on their own journey of understanding and growth is essential in fostering healthy and supportive relationships.

Consider the dynamics of a romantic relationship where one partner is more woke than the other. This can create tension and misunderstandings, especially if one partner feels judged or misunderstood. The key is to approach these differences with empathy and a willingness to learn from each other.

This might involve having open and honest conversations about each other's beliefs and experiences, finding common ground, and respecting each other's perspectives. By approaching the relationship with a sense of curiosity and mutual respect, couples can navigate ideological differences without compromising the integrity of their relationship.

In friendships, ideological differences can also create challenges. Friends who once bonded over shared interests and experiences may find themselves at odds over woke issues. The key to maintaining these friendships is to focus on the qualities that brought you together in the first place.

It might involve engaging in activities that you both enjoy, avoiding contentious topics, and finding ways to support each other despite your differences. It's about recognizing that true friendship is built on more than just shared beliefs; it's about mutual respect, trust, and support.

In the professional world, the influence of wokeness can create a complex landscape to navigate. Colleagues may have differing views on social justice issues, and these differences can impact workplace dynamics. The key to maintaining a harmonious work environment is to foster a culture of respect and inclusivity. This involves promoting open dialogue, encouraging diverse perspectives, and creating a supportive environment where everyone feels valued. By prioritizing professionalism and mutual respect, colleagues can navigate ideological differences without compromising the integrity of the workplace. To change their minds and end wokeness one must use knowledge as a sword and slash away at their moronic concepts.

To address the challenges of wokeness in family and personal relationships, several strategies can be considered. First and foremost, it is essential again I say to cultivate a culture of empathy and

understanding. This involves recognizing and respecting the experiences and perspectives of others, even if they differ from your own. By approaching conversations with an open mind and a willingness to learn, you can foster greater understanding and connection. Using Your mind as weapon its easy to call out the bullshit.

Another important strategy is to establish clear boundaries and guidelines for discussions. This can involve setting ground rules for conversations, such as avoiding certain contentious topics or agreeing to disagree on specific issues. By creating a framework for respectful dialogue, you can prevent arguments from escalating and ensure that everyone feels heard and valued although the woke mind virus victim may be hard to deal with.

Focusing on shared values and experiences is another effective approach. Despite ideological differences, families and friends

often have common values and traditions that can serve as a foundation for connection. By emphasizing these shared aspects, you can build a sense of unity and mutual respect.

Education and open-mindedness are also critical in navigating the effects of wokeness on family and personal relationships. Encouraging yourself and others to educate yourselves on different perspectives and engage in open-minded dialogue can foster greater understanding and empathy ultimately changing the woke victims mind. This involves listening actively, asking questions. The right question can turn someone from Woke to sane in an instant.

One practical strategy is to develop and implement educational programs that focus on the intersection of family dynamics and social justice. These programs can be designed to educate family members about

the principles of social justice, while also grounding these principles in the values and traditions of the family. By providing a framework for understanding and addressing social justice issues, these programs can help to bridge the gap between wokeness and family values. This approach involves integrating social justice education into family activities, discussions, and traditions, creating a holistic and comprehensive understanding of these issues.

Finally, it is essential to cultivate a culture of continuous learning and growth within families and personal relationships. This involves encouraging individuals to engage in ongoing education and reflection on issues of justice and personal connections. Families and friends can promote a culture of learning by offering educational programs, hosting guest speakers, and providing resources for further study. By fostering a mindset of curiosity and openness, families and personal

relationships can create an environment where individuals feel empowered to explore and grow in their understanding of these complex issues.

The influence of wokeness on family dynamics and personal relationships presents a complex and challenging landscape. The tensions between these powerful forces have created conflicts within families and personal connections, as individuals grapple with how to reconcile their beliefs with the demands of social justice. By implementing practical strategies such as education, intergenerational dialogue, community-building initiatives, creativity and innovation, mentorship and support networks, clear guidelines, effective media communication, and a culture of continuous learning, families and personal relationships can navigate these complexities and promote a balanced approach to social justice. Ending the influence of woke culture on family dynamics and personal relationships requires a collective effort, a commitment to

principles, and a willingness to engage with difficult and contentious issues. By doing so, we can ensure that families and personal relationships continue to be spaces of connection, support, and growth, while also promoting justice and equality in society. This journey is not just about addressing the challenges of the present but also about building a foundation for a more inclusive and compassionate future.

Chapter 13: The Psychological Impact

In the echo chamber of woke culture, where every whisper is scrutinized and every shout is amplified, the human psyche bears the brunt of the relentless pressure to conform. The utopian dream of a just and equitable society has morphed into a dystopian reality for many, where the mental toll is palpable.

Stress, anxiety, and the suffocating weight of constant vigilance against perceived transgressions take a heavy toll on individuals trying to navigate this ideological minefield. The psychological impact of living in a woke culture is profound, affecting not just individual well-being but also the collective mental health of society.

Picture the mind as a delicate ecosystem, a vibrant rainforest teeming with thoughts, emotions, and memories. Now imagine an invasive species—woke ideology—

spreading like kudzu, choking out native flora and fauna. The result is an unbalanced and stressed environment, struggling to maintain its natural harmony. The mental landscape of those ensnared by wokeness is fraught with tension, as they constantly monitor themselves and others for any hint of ideological impurity.

One of the most insidious effects of woke culture is the pervasive sense of stress and anxiety it induces. The pressure to adhere to ever-evolving woke standards creates a state of constant hypervigilance.

Individuals feel compelled to scrutinize their words, actions, and even thoughts for any potential missteps. This self-surveillance is exhausting, leading to chronic stress and a heightened sense of anxiety. The fear of being "cancelled" or ostracized for a perceived infraction looms large, casting a shadow over every social interaction.

Consider the experience of a college student, eager to engage in intellectual exploration and debate. In a woke environment, this pursuit is fraught with peril. A careless remark or an unpopular opinion can trigger a social media firestorm, complete with accusations of bigotry and calls for expulsion. The student, once excited about learning, now tiptoes through academic discussions, wary of saying anything that might be deemed offensive. The joy of discovery is replaced by the dread of misstep, and the student's mental health suffers as a result.

The pressure to conform to woke standards extends beyond academia into the workplace, social circles, and even the family unit. Employees are often required to undergo sensitivity training sessions that, while well-intentioned, can feel like ideological indoctrination. The workplace becomes a theater of performance, where individuals must constantly signal their virtue to avoid professional repercussions.

This performative aspect of wokeness fosters a sense of inauthenticity, as people feel compelled to present a curated version of themselves that aligns with woke values.

The psychological toll of this constant performance is significant. Individuals experience cognitive dissonance, the mental discomfort that arises from holding contradictory beliefs or behaviors. The pressure to conform to woke standards often clashes with one's personal beliefs and values, creating an internal conflict that exacerbates stress and anxiety. The sense of being trapped in a web of expectations, where authenticity is sacrificed for acceptance, can lead to feelings of isolation and alienation.

Social media, that omnipresent arbiter of public opinion, amplifies the psychological impact of woke culture. Platforms like Twitter, Facebook, and Instagram become

battlegrounds where ideological purity is policed with fervor. The fear of public shaming or "cancel culture" drives individuals to meticulously curate their online personas, further entrenching the sense of inauthenticity. The dopamine hit from likes and retweets becomes a fleeting balm for the anxiety and stress of living under constant scrutiny.

The phenomenon of "call-out culture" adds another layer of psychological pressure. The act of publicly shaming someone for a perceived transgression, often based on incomplete or misunderstood information, creates a climate of fear and mistrust. Individuals become wary of engaging in open dialogue, lest they become the next target of a digital witch hunt. The psychological impact of being "called out" can be devastating, leading to a sense of humiliation, anxiety, and depression.

The impact of woke culture on mental health is not limited to those who actively

participate in or are targeted by its mechanisms. Bystanders, too, are affected by the pervasive climate of fear and tension. The constant barrage of woke rhetoric and the ever-present threat of social or professional repercussions create a generalized sense of anxiety. The social fabric, once a tapestry of diverse thoughts and opinions, becomes frayed as individuals retreat into self-censorship and silence.

To address the psychological impact of woke culture, several strategies can be considered. First and foremost, it is essential to foster an environment that values mental well-being and resilience. This involves creating spaces where individuals feel safe to express their thoughts and opinions without fear of retribution.

When promoting a culture of open dialogue and mutual respect, we can alleviate the stress and anxiety associated with ideological conformity.

One practical approach is to incorporate mental health education and support into workplaces, educational institutions, and communities. Providing resources such as counseling services, stress management workshops, and mental health awareness programs can help individuals cope with the pressures of woke culture. By prioritizing mental well-being, we can create a more supportive and resilient environment.

Encouraging critical thinking and intellectual independence is another important strategy. Individuals should be empowered to question and challenge prevailing ideologies, including woke culture, without fear of reprisal. This involves promoting a culture of skepticism and inquiry, where diverse perspectives are valued and explored.

When we are fostering intellectual curiosity and resilience, we can counteract the homogenizing influence of woke ideology.

The role of humor and satire in mitigating the psychological impact of woke culture cannot be overstated.

Incorporating mindfulness and self-care practices into daily life can also help mitigate the psychological impact of woke culture. Techniques such as meditation, deep breathing exercises, and journaling can reduce stress and promote emotional well-being. Encouraging individuals to prioritize self-care and develop healthy coping mechanisms can enhance resilience and mental health.

Promoting a balanced and nuanced approach to social justice is essential in addressing the psychological toll of woke culture. This involves recognizing the importance of justice and equality while also valuing

individual well-being and mental health. By fostering a more compassionate and empathetic approach to social justice, we can create an environment where individuals feel supported rather than pressured to conform no not being a woketard.

Public awareness and education are also crucial in addressing the psychological effects of woke culture. By raising awareness about the mental health challenges associated with ideological conformity and promoting resources for support and resilience, we can create a more informed and compassionate society void of wokeness. Public education campaigns, workshops, and community discussions can help individuals understand the impact of woke culture on mental health and provide strategies for coping and resilience.

To further explore the psychological impact of woke culture and develop effective strategies for mitigating its effects, we must delve deeper into the experiences and

perspectives of individuals affected by this phenomenon. By understanding the diverse ways in which woke culture influences mental health, we can develop more targeted and effective interventions.

One important area of focus is the experience of marginalized and underrepresented groups within woke culture. While woke ideology often aims to advocate for the rights and well-being of these groups, it can also create additional pressures and challenges. For example, individuals from marginalized backgrounds may feel burdened by the expectation to represent and advocate for their entire community. This can lead to feelings of tokenism, isolation, and burnout. By recognizing and addressing these unique challenges, we can develop more supportive and inclusive approaches to social justice. The groups must learn to be individuals and not just a member of the herd.

Another important consideration is the experience of individuals who hold minority or dissenting opinions within woke culture. The pressure to conform to prevailing ideologies can be particularly intense for those whose views differ from the mainstream. These individuals may face social ostracism, professional repercussions, and mental health challenges as a result of their dissenting opinions. By fostering a culture of intellectual diversity and open dialogue, we can create a more inclusive environment where diverse perspectives are valued and respected.

The role of social media in amplifying the psychological impact of woke culture is another critical area of focus. Platforms like Twitter, Facebook, and Instagram create a constant stream of woke rhetoric and public shaming, exacerbating the pressure to conform.

Understanding the ways in which social media influences mental health and

developing strategies for healthy online engagement can help mitigate these effects. This might involve promoting digital literacy, encouraging mindful social media use, and creating online spaces that prioritize respectful and constructive dialogue.

The intersection of woke culture and mental health in professional settings is another important area to explore. Employees in woke environments may experience heightened stress and anxiety due to the pressure to adhere to ideological standards. Developing workplace policies and practices that prioritize mental well-being, promote open dialogue, and support diverse perspectives can help create a healthier and more supportive professional environment. After all once You go woke, You're likely to go broke.

The psychological impact of woke culture on young people and students is a critical area of concern. Adolescents and young

adults are particularly vulnerable to the pressures of ideological conformity, as they navigate their identities and social relationships. Educational institutions must prioritize mental health support, promote critical thinking, and create safe spaces for open dialogue. By providing resources and support for students to navigate these challenges, we can foster resilience and well-being.

Finally, the role of self-reflection and personal growth in mitigating the psychological impact of woke culture cannot be overlooked.

Encouraging individuals to engage in self-reflection, explore their values and beliefs, and develop a sense of self-awareness can help them navigate the pressures of ideological conformity. We are all individuals. Personal growth practices, such as mindfulness, meditation, and journaling, can promote emotional well-being and resilience to woke ideas.

The psychological impact of living in a woke culture is profound and multifaceted. The pressure to conform to ideological standards creates stress, anxiety, and a sense of inauthenticity, affecting individual well-being and collective mental health. By allowing an environment that values mental well-being, promoting critical thinking and intellectual independence, leveraging humor and satire, building strong social support networks, incorporating mindfulness and self-care practices, promoting a balanced approach to social justice, and demonstrating compassionate leadership, we can mitigate the psychological toll of woke culture and promote a more supportive and resilient society.

This trip requires a collective effort, a commitment to principles, and a willingness to engage with difficult and contentious issues. When doing so, we can ensure that individuals feel empowered to navigate the challenges of woke culture while

maintaining their mental health and well-being.

This journey is not just about addressing the challenges of the present but also about building a foundation for a more inclusive, compassionate, and mentally healthy future.

Chapter 13: The Psychological Impact

In the theater of woke culture, the stage is set not just for public performances but for an intricate dance of inner turmoil. The relentless pressure to conform, the ever-watchful eyes ready to pounce on any misstep, and the pervasive fear of social ostracism cast long shadows over the human psyche. Living in a world where every word and action are scrutinized under the harsh light of ideological purity takes a profound toll on mental health, manifesting as stress, anxiety, and a deep-seated feeling of alienation.

Picture the mind as an elaborate mansion, each room filled with the furniture of thoughts, emotions, and memories. Now imagine the woke ideology as an overbearing interior decorator, demanding that every piece of furniture be rearranged according to a strict, ever-changing set of rules. The result is chaos, where the once harmonious and comfortable space becomes

a claustrophobic labyrinth of anxiety and self-censorship.

The first casualty in the war of woke culture is often peace of mind. The pressure to adhere to a rigid set of ideological standards creates a state of constant hypervigilance. Individuals are forced to scrutinize their own thoughts and behaviors, perpetually on guard against any slip that might be deemed offensive or problematic. This self-surveillance is mentally exhausting, leading to chronic stress and a heightened sense of anxiety.

Consider the plight of a university student, eager to engage in robust intellectual debate and explore new ideas. In a woke environment, this pursuit becomes fraught with danger. A single misinterpreted comment or a question perceived as insensitive can trigger a social media storm, complete with accusations of bigotry and calls for disciplinary action.

The student, once enthusiastic about learning, now treads carefully, weighed down by the fear of making a mistake. The joy of discovery is replaced by a gnawing dread, and the student's mental health suffers as a result.

The workplace, too, is not immune to the psychological impact of woke culture. Employees are often required to participate in sensitivity training sessions that, while ostensibly well-meaning, can feel like ideological re-education camps. The workplace transforms into a stage where every interaction is a performance, and individuals must constantly demonstrate their alignment with woke values to avoid professional repercussions. This performative aspect of wokeness fosters a sense of inauthenticity, as people feel compelled to present a curated version of themselves that aligns with the dominant ideology.

The psychological toll of this constant performance is significant. Individuals experience cognitive dissonance, the mental discomfort that arises from holding contradictory beliefs or behaviors.

The pressure to conform to woke standards often clashes with one's personal beliefs and values, creating an internal conflict that exacerbates stress and anxiety. The sense of being trapped in a web of expectations, where authenticity is sacrificed for acceptance, can lead to feelings of isolation and alienation.

The impact of woke culture on mental health is not limited to those who actively participate in or are targeted by its mechanisms. Bystanders, too, are affected by the pervasive climate of fear and tension. The constant barrage of woke rhetoric and the ever-present threat of social or professional repercussions create a generalized sense of anxiety. The social fabric, once a tapestry of diverse thoughts

and opinions, becomes frayed as individuals retreat into self-censorship and silence.

To address the psychological impact of woke culture, several strategies can be considered. First and foremost, it is essential to foster an environment that values mental well-being and resilience. This involves creating spaces where individuals feel safe to express their thoughts and opinions without fear of retribution. By promoting a culture of open dialogue and mutual respect, we can alleviate the stress and anxiety associated with ideological conformity.

One practical approach is to incorporate mental health education and support into workplaces, educational institutions, and communities. Providing resources such as counseling services, stress management workshops, and mental health awareness programs can help individuals cope with the pressures of woke culture.

Encouraging critical thinking and intellectual independence is another important strategy. Individuals should be empowered to question and challenge prevailing ideologies, including woke culture, without fear of reprisal. This involves promoting a culture of skepticism and inquiry, where diverse perspectives are valued and explored. By fostering intellectual curiosity and resilience, we can counteract the homogenizing influence of woke ideology.

The role of humor and satire in mitigating the psychological impact of woke culture cannot be overstated. Humor has a unique ability to cut through tension and reveal underlying truths. Satire, in particular, can challenge the absurdities and contradictions of woke culture, providing a release valve for the pressure to conform.

By using humor to critique woke ideology, we can create a more relaxed and open

environment where individuals feel free to express themselves authentically.

Social support networks play a crucial role in maintaining mental well-being in the face of woke pressure. Building and nurturing strong relationships with friends, family, and like-minded individuals can provide a buffer against the stress and anxiety of ideological conformity.

These support networks offer a safe space for individuals to share their experiences, seek advice, and find solidarity. By fostering a sense of community and belonging, we can help individuals navigate the challenges of woke culture more effectively.

Incorporating mindfulness and self-care practices into daily life can also help mitigate the psychological impact of woke culture. Techniques such as meditation, deep breathing exercises, and journaling can reduce stress and promote emotional well-

being. Encouraging individuals to prioritize self-care and develop healthy coping mechanisms can enhance resilience and mental health.

Promoting a balanced and nuanced approach to social justice is essential in addressing the psychological toll of woke culture. This involves recognizing the importance of justice and equality while also valuing individual well-being and mental health. Always try fostering a more compassionate and empathetic approach to social justice, we can create an environment where individuals feel supported rather than pressured to conform ending wokeness.

Public awareness and education are also crucial in addressing the psychological effects of woke culture. By raising awareness about the mental health challenges associated with ideological conformity and promoting resources for support and resilience, we can create a more informed and compassionate society.

Public education campaigns, workshops, and community discussions must be developed and can help individuals understand the impact of woke culture on mental health and provide strategies for coping and resilience.

To further explore the psychological impact of woke culture and develop effective strategies for mitigating its effects, we must delve deeper into the experiences and perspectives of individuals affected by this phenomenon. By understanding the diverse ways in which woke culture influences mental health, we can develop more targeted and effective interventions.

One important area of focus is the experience of marginalized and underrepresented groups within woke culture. While woke ideology often aims to advocate for the rights and well-being of these groups, it can also create additional pressures and challenges. For example, individuals from marginalized backgrounds may feel burdened by the expectation to

represent and advocate for their entire community. This can lead to feelings of tokenism, isolation, and burnout. By recognizing and addressing these unique challenges, we can develop more supportive and inclusive approaches to social justice.

Another important consideration is the experience of individuals who hold minority or dissenting opinions within woke culture. The pressure to conform to prevailing ideologies can be particularly intense for those whose views differ from the mainstream. These individuals may face social ostracism, professional repercussions, and mental health challenges as a result of their dissenting opinions. When fostering a culture of intellectual diversity and open dialogue, we can create a more inclusive environment where diverse perspectives are valued and respected.

The intersection of woke culture and mental health in professional settings is another important area to explore. Employees in woke environments may experience heightened stress and anxiety due to the pressure to adhere to ideological standards.

Finally, the role of self-reflection and personal growth in mitigating the psychological impact of woke culture cannot be overlooked. Encouraging individuals to engage in self-reflection, explore their values and beliefs, and develop a sense of self-awareness can help them navigate the pressures of ideological conformity.

Personal growth practices, such as mindfulness, meditation, and journaling, can promote emotional well-being and resilience.

The psychological impact of living in a woke culture is profound and multifaceted. The pressure to conform to ideological standards creates stress, anxiety, and a sense of inauthenticity, affecting individual well-being and collective mental health. Continue fostering an environment that values mental well-being, promote critical thinking and intellectual independence, leveraging humor and satire, building strong social support networks, incorporating mindfulness and self-care practices, promoting a balanced approach to social justice, and demonstrating compassionate leadership, we can mitigate the psychological toll of woke culture and promote a more supportive and resilient society without wokeness. This requires a collective effort, a commitment to principles, and a willingness to engage with difficult and contentious issues.

By doing so, we can ensure that individuals feel empowered to navigate the challenges of woke culture while maintaining their mental health and well-being. This journey is not just about addressing the challenges of

the present but also about building a foundation for a more inclusive, compassionate, and mentally healthy future without wokeness.

Chapter 14: The Global Perspective

In the global bazaar of ideas, where cultures collide and philosophies jostle for dominance, wokeness has emerged as a curious vendor, hawking its wares from the corners of cosmopolitan metropolises to the quiet alleys of ancient cities.

Its presence is felt everywhere, but its manifestation is as diverse as the tapestry of humanity itself. As we embark on this chapter, we'll traverse continents to explore how different nations are contending with the ideological shifts brought by wokeness, and we'll uncover strategies to dismantle its pervasive influence in a way that respects the unique contexts of each society.

In the United States, wokeness is a roaring bonfire, casting long shadows over every aspect of public life. The American variant is a fervent crusade, driven by a relentless pursuit of social justice that often teeters

into the realm of zealotry. Here, the focus is intensely on identity politics, systemic inequality, and a call-out culture that spares no one in its quest for ideological purity. Universities, corporate boardrooms, and social media platforms have become the battlegrounds where these ideological wars are fought, often leaving behind a trail of polarization and discord.

Across the Atlantic, the United Kingdom presents a more subdued yet equally complex picture. The British iteration of wokeness is marked by a tension between traditional values of free speech and the contemporary demands for inclusivity and representation. The British press, known for its sharp wit and appetite for controversy, frequently highlights the more absurd aspects of woke culture, while universities and public institutions adopt policies mirroring their American counterparts. The result is a cultural tug-of-war, where the stiff upper lip of British restraint clashes with the fervor of social justice activism.

In France, wokeness faces a unique challenge from the country's staunch commitment to laïcité, or secularism. This principle, emphasizing the separation of religion and state and the universal application of laws, often finds itself at odds with the identity-focused aspects of woke ideology.

French intellectuals and policy makers are engaged in heated debates, trying to reconcile these conflicting ideologies within a framework that respects France's deep-seated values of liberty, equality, and fraternity. Public protests and intellectual discourse reflect this ongoing struggle to balance traditional secularism with modern social justice demands.

Traveling eastward to Japan, we encounter a society that places immense value on harmony and social cohesion. Here,

wokeness is not as overtly confrontational as in the West.

Japanese culture, with its emphasis on group harmony (wa) and respect for social norms, approaches social justice issues with a quiet, steady determination. Efforts to address gender equality and workplace discrimination are underway, but they are implemented in a way that seeks to integrate these changes into the fabric of societal harmony rather than disrupt it.

India, with its rich cultural heritage and complex social dynamics, presents a multifaceted landscape for wokeness. Issues of caste-based discrimination, gender inequality, and religious tensions are long-standing challenges that intersect with woke ideology in intricate ways. Indian activists and intellectuals work to promote social justice while navigating the delicate balance of preserving the country's diverse cultural identity.

The task is monumental, requiring a nuanced approach that considers the deep-rooted historical and social contexts unique to India.

In Africa, the influence of wokeness varies widely across the continent's many nations. In South Africa, with its painful history of apartheid and ongoing struggles with racial inequality, woke ideology resonates deeply, emphasizing themes of decolonization and racial justice. However, in other parts of Africa, the focus on identity politics can sometimes clash with pressing issues of economic development and political stability. Many parts of Africa wokeness is laughable. The challenge lies in addressing these urgent needs without allowing the divisive aspects of woke ideology to take root and disrupt social cohesion in such pure places.

Latin America, with its legacy of colonialism, political turmoil, and economic disparity, offers another unique perspective. Countries like Brazil, Argentina, and Mexico grapple with issues of racial and gender inequality, indigenous rights, and social justice. Here, woke ideology finds both enthusiastic supporters and staunch critics.

The task is to address these deep-seated issues in a manner that fosters unity and progress rather than exacerbating existing social divisions.

To effectively address the global impact of wokeness and develop strategies for mitigating its influence, we must consider the unique cultural, social, and political contexts of each country. If we can begin understanding these nuances, we can devise more effective and targeted interventions that promote social justice while preserving cultural values and social harmony all the while destroying wokeness at its core.

One potential strategy is to foster cross-cultural dialogue and exchange. By promoting conversations between different cultures and societies, we can share best practices, learn from each other's experiences, and develop more holistic approaches to social justice. This involves creating platforms for international collaboration, where policymakers, activists, and intellectuals can come together to discuss the challenges and opportunities presented by woke ideology.

Another important approach is to emphasize education and critical thinking. Societies must invest in educational systems that promote intellectual independence and skepticism, encouraging individuals to question prevailing ideologies and form their own informed opinions. This includes incorporating lessons on the history and philosophy of social justice movements, as well as the importance of balancing these ideals with other fundamental values such as freedom of speech and individual rights.

In addition once again I must repeat, fostering a culture of empathy and mutual respect is crucial. By encouraging individuals to listen to and understand different perspectives, we can create a more inclusive environment where diverse viewpoints are valued. This involves promoting dialogue and understanding across cultural and ideological divides, and working to bridge gaps rather than deepen them. We can only change these people's minds if we pretend to act like they are not insane with woke issues.

One potential strategy is to foster cross-cultural dialogue and exchange. By promoting conversations between different cultures and societies, we can share best practices, learn from each other's experiences, and develop more holistic approaches to social justice. This involves creating platforms for international collaboration, where policymakers, activists, and intellectuals can come together to

discuss the challenges and opportunities presented by woke ideology.

Another important approach is to emphasize education and critical thinking. Societies must invest in educational systems that promote intellectual independence and skepticism, encouraging individuals to question prevailing ideologies and form their own informed opinions. This includes incorporating lessons on the history and philosophy of social justice movements, as well as the importance of balancing these ideals with other fundamental values such as freedom of speech and individual rights.

In addition, fostering a culture of empathy and mutual respect is crucial. By encouraging individuals to listen to and understand different perspectives, we can create a more inclusive environment where diverse viewpoints are valued. This involves promoting dialogue and understanding across cultural and ideological divides

working to bridge gaps rather than deepen them.

The global perspective on wokeness reveals a diverse and complex landscape, where different countries and cultures grapple with the influence of woke ideology in unique ways. By understanding these nuances and developing targeted strategies, we can promote social justice while preserving cultural values and social harmony.

Chapter 15: Resistance and Backlash

In the shadowy back alleys of public discourse, where dissent whispers and roars against the cacophony of mainstream ideology, a resistance is brewing. This rebellion against the relentless march of wokeness manifests in various forms, from grassroots movements to outspoken figures, each armed with their unique arsenal of wit, reason, and defiance.

In this chapter, we delve into the vibrant landscape of resistance and backlash, exploring the strategies employed by those who dare to push back against the tide of woke culture.

The resistance to wokeness is not a monolithic force but a mosaic of diverse voices, each challenging the prevailing narrative in their own way. At the grassroots level, communities and individuals are

organizing to reclaim spaces for free thought and open dialogue.

These efforts often begin in the quiet corners of the internet, on forums and social media groups where like-minded individuals gather to share their frustrations and strategize.

What starts as a murmur of discontent can quickly swell into a roar of collective action.

Take, for instance, the rise of local advocacy groups that champion free speech and academic freedom. These organizations often emerge in response to perceived overreach by institutions enforcing woke policies.

They organize rallies, hold town hall meetings, and launch campaigns to raise awareness about the importance of preserving open discourse. By mobilizing their communities, these grassroots movements challenge the encroachment of

ideological conformity and advocate for a more balanced approach to social justice.

One notable example is the Foundation for Individual Rights in Education (FIRE), a U.S.-based organization dedicated to defending civil liberties in academia. FIRE has become a formidable force in pushing back against campus censorship and advocating for the rights of students and faculty. Through legal action, public advocacy, and educational outreach, FIRE works to uphold the principles of free speech and academic freedom, challenging the restrictive policies that often accompany woke culture in higher education.

Prominent figures also play a crucial role in the resistance against wokeness. These individuals, often public intellectuals, authors, and commentators, use their platforms to voice dissent and critique the excesses of woke ideology. Their influence can be far-reaching, as they engage in debates, write op-eds, and participate in

media interviews, offering alternative perspectives and challenging the dominant narrative.

Consider the case of Jordan Peterson, a Canadian psychologist and professor who gained international prominence for his outspoken criticism of compelled speech and identity politics. Peterson's articulate and passionate defense of free speech and individual rights has resonated with millions, making him a central figure in the pushback against wokeness. His lectures, books, and public appearances have sparked widespread discussion and debate, inspiring others to question and critique woke ideology.

Another significant figure in this landscape is Bari Weiss, a journalist and author who has been vocal about the dangers of ideological conformity in the media and academia. Weiss's resignation from The New York Times in protest of what she described as a culture of intimidation and

censorship highlighted the growing resistance within the journalistic community.

Her writings and public statements continue to shed light on the challenges faced by those who dissent from woke orthodoxy, encouraging a broader conversation about intellectual diversity and freedom of expression.

The strategies employed by these prominent figures and grassroots movements are diverse and multifaceted. One common approach is to point out the absurdities and contradictions of woke culture. When You are highlighting the ridiculous extremes to which woke ideology can sometimes go, we can provoke reflection and discussion, undermining the perceived authority of woke rhetoric. These people stand on the shoulders of giants and pretend to be tall.

Comedy can be a powerful tool in breaking down the walls of ideological conformity. Shows like "South Park" and comedians like Dave Chappelle have used satire to critique woke culture, drawing attention to its more ludicrous aspects and challenging audiences to think critically about the issues at hand.

By using humor to point out the flaws and inconsistencies in woke ideology, they create a space for open dialogue and critical reflection.

Another effective strategy is the promotion of open dialogue and intellectual diversity. This involves creating platforms and spaces where individuals from diverse backgrounds and perspectives can engage in meaningful discussions about social justice and other contentious issues. By fostering an environment where different viewpoints are valued and respected, these initiatives challenge the homogenizing influence of woke culture and promote a more inclusive approach to discourse.

Organizations like the Heterodox Academy advocate for viewpoint diversity in academia, encouraging universities to embrace intellectual diversity and create spaces for open dialogue. By promoting policies and practices that support free expression and critical inquiry, these organizations work to counteract the restrictive tendencies of woke culture and foster a more vibrant and inclusive academic environment.

Legal action is another crucial component of the resistance against wokeness. Challenging restrictive policies and practices through the courts, individuals and organizations can push back against the overreach of woke ideology and uphold the principles of free speech and individual rights.

Legal battles over issues such as campus censorship, compelled speech, and

discriminatory policies highlight the ongoing struggle to preserve fundamental freedoms in the face of ideological pressure.

In addition to these strategies, it is essential to promote education and critical thinking as antidotes to ideological conformity. By encouraging individuals to question prevailing narratives and think independently, we can cultivate a more informed and discerning public who are against wokeness. This involves promoting media literacy, teaching critical thinking skills, and fostering a culture of intellectual curiosity and skepticism.

Educational initiatives that emphasize the importance of free thought and open inquiry can help counteract the influence of woke ideology. Programs that teach students to engage with diverse perspectives, analyze arguments critically, and develop their own informed opinions can create a foundation for intellectual resilience.

The role of technology in the resistance against wokeness cannot be overlooked either. The internet and social media provide powerful tools for organizing, mobilizing, and amplifying dissenting voices.

Online platforms allow individuals and groups to connect, share information, and coordinate actions, creating a decentralized and dynamic resistance movement. However, it is also important to recognize the challenges posed by digital censorship and algorithmic bias, which can stifle dissent and reinforce ideological conformity.

To address these challenges, it is essential to advocate for digital rights and freedoms, promoting policies that protect free expression and prevent undue censorship by technology companies.

By ensuring that online platforms remain open and accessible to diverse viewpoints, we can harness the power of technology to

support the resistance against wokeness and promote a more inclusive and open digital environment.

In exploring the various forms of resistance and backlash against wokeness, it is important to recognize that this movement is not monolithic. The resistance encompasses a wide range of voices and perspectives, each with its own unique approach and strategy. By understanding and supporting these diverse efforts, we can create a more effective and cohesive resistance movement that challenges the excesses of woke culture and promotes a more balanced and inclusive approach to social justice and not blind wokeness.

As we navigate this complex landscape, it is essential to remain vigilant and proactive in defending the principles of free speech, intellectual diversity, and individual rights. We must continue fostering a culture of open dialogue, critical thinking, and mutual respect, we can counteract the homogenizing

influence of woke ideology and create a more inclusive and vibrant society.

This requires a collective effort, a commitment to principles, and a willingness to engage with difficult and contentious issues.

Resistance and backlash against wokeness represents a dynamic and multifaceted movement, driven by a diverse array of voices and strategies. From grassroots movements and local advocacy groups to prominent public figures and legal battles, the resistance is united by a common goal: to challenge the excesses of woke culture and promote a more balanced and inclusive approach to social justice not mob mentality.

Chapter 16: Pathways to Balance

The kaleidoscope of woke culture is akin to walking a tightrope over a chasm. The stakes are high, and the fall can be devastating. But with careful planning, a firm grip on principles, and a dash of daring, it is possible to navigate this precarious landscape.

This chapter explores potential solutions and strategies to foster open dialogue, critical thinking, and mutual respect, aiming to restore equilibrium in a world increasingly dominated by woke ideological extremes.

Imagine the world of ideas as a bustling marketplace, filled with vibrant stalls of diverse thoughts and perspectives. Each stall offers something unique, a fresh take on life, a novel solution to age-old problems. In this marketplace, balance is achieved not by silencing the noisy vendors but by

encouraging a rich and diverse exchange of ideas.

The first step towards balance to give at least a glimpse of ending wokeness as I have repeatedly stated is to promote open dialogue, ensuring that all voices, even the dissenting ones, have a place in the conversation.

One effective strategy for fostering open dialogue is to create safe spaces for discussion, where individuals can express their thoughts and opinions without fear of retribution. These spaces, whether physical or virtual, should be designed to encourage respectful and constructive conversations. Universities, workplaces, and community centers can establish forums, discussion groups, and workshops dedicated to exploring contentious issues in a balanced and open-minded manner.

Take the example of the "Free Speech Cafés" that have sprung up in various parts of the world. These informal gatherings bring together people from different backgrounds and perspectives to discuss controversial topics over coffee.

The relaxed atmosphere and the absence of formal structures encourage genuine dialogue and the exchange of ideas. Participants are encouraged to listen actively, ask questions, and challenge their own assumptions, creating a culture of intellectual curiosity and respect.

Another crucial aspect of promoting open dialogue is the role of education. Educational institutions must prioritize teaching critical thinking skills, equipping students with the tools to analyze arguments, evaluate evidence, and form their own informed opinions. This involves moving beyond rote learning and encouraging a more inquiry-based approach to education.

Curriculum reform is a key component of this strategy. Schools should incorporate lessons on media literacy, logical reasoning, and ethical decision-making into their curricula. These subjects can help students navigate the complex landscape of modern discourse, discerning fact from opinion and recognizing the nuances of different arguments. By developing these skills, students can become more discerning consumers of information and more effective participants in public discourse.

In addition to formal education, public awareness campaigns can play a significant role in promoting critical thinking and open dialogue. These campaigns can use various media platforms to highlight the importance of intellectual diversity and encourage people to engage with different perspectives.

By showcasing stories of individuals who have successfully navigated ideological

divides and fostering a culture of empathy and respect, these campaigns can help shift public attitudes towards a more balanced and inclusive approach to discourse.

Another effective method is to promote community-building initiatives that bring people together in meaningful and collaborative ways. Community service projects, cultural exchanges, and recreational activities can help individuals from different backgrounds and perspectives connect on a personal level.

By working together towards common goals, people can build relationships based on mutual respect and understanding, breaking down the barriers that often divide us. Wokeness is a mind virus. Common sense is the only remedy to this plaque.

It is essential to address the structural and systemic factors that contribute to ideological polarization. This involves implementing policies and practices that promote social and economic equity, ensuring that all individuals have access to opportunities and resources regardless of skin color, creed or religion.

When we are addressing the root causes of inequality and other true social issues, we can reduce the tensions and frustrations that often fuel ideological divides finding common ground. The far left wants us apart, not together. It is classic divide and conquer.

One important aspect to end wokeness is promoting individual responsibility and to encourage civic engagement and participation by setting good examples ourselves. We after all allowed wokeness to thrive in the first place. It's our job to be brave and stand up against the woke mobs that so often have reached the upper echelons of society and govenment.

Finding balance in a woke world requires a multifaceted approach for future of us all.

Chapter 17: Envisioning a Post-Woke Future

Picture a world painted with the vibrant hues of shared understanding, where the cacophony of competing ideologies has mellowed into a symphony of diverse perspectives. Here lies the vision of a post-woke society, where the rigid dogmas of today have dissolved, making way for an era defined by inclusivity, rationality, and cohesion.

This chapter imagines such a future, offering potential solutions and strategies for dismantling the extremes of wokeness and building a more harmonious world.

In this envisioned future, wokeness is dead. Imagine public squares bustling with discussions, not dominated by the loudest voices but enriched by a chorus of diverse opinions.

Intellectual humility becomes the norm, where acknowledging the limits of one's knowledge is seen as a strength rather than a weakness. This culture encourages people to engage in conversations that challenge their viewpoints, fostering an environment where learning and growth are celebrated.

Educational institutions play a pivotal role in this transformation. Schools and universities become sanctuaries of critical thinking, where students are taught not what to think, but how to think. Curricula are designed to include a broad spectrum of voices and perspectives, encouraging students to explore complex issues from multiple angles.

This approach helps students develop the skills necessary to navigate the intricate landscape of modern society with confidence and discernment.

Consider a classroom where students debate contentious topics with vigor and respect, guided by educators who value inquiry over indoctrination.

These students learn to appreciate the nuances of different arguments, to analyze evidence critically, and to form their own informed opinions. This educational philosophy empowers individuals to become independent thinkers, capable of engaging with diverse perspectives and contributing to a more inclusive and balanced society without wokeness.

Beyond the classroom, public awareness campaigns and media initiatives play a crucial role in promoting critical thinking and intellectual diversity. Imagine a media landscape where content creators prioritize thoughtful analysis and respectful debate over sensationalism and outrage.

News outlets and social media platforms foster a culture of curiosity, encouraging audiences to explore different viewpoints and engage in meaningful conversations. By promoting intellectual diversity and discouraging echo chambers, these platforms help create a more informed and discerning public.

In this post-woke society, the role of humor and satire is celebrated. Comedians and satirists use their craft to highlight the absurdities of ideological extremism of the past, provoking reflection and discussion.

Imagine comedy clubs and late-night shows where humor serves as a catalyst for critical thinking, challenging audiences to question their assumptions and see the world in a new light. Satire becomes a powerful tool for promoting intellectual humility and encouraging open dialogue on ending wokeness. It's not a crime to have Your feelings hurt and You can't please everyone.

Community-building initiatives are also central to this vision. Local organizations and grassroots movements work to strengthen social bonds and create inclusive, supportive communities. These efforts are driven by a commitment to mutual aid and solidarity, recognizing that the well-being of individuals is intertwined with the health of the broader community. Imagine neighborhoods where people from diverse backgrounds come together to work on common projects, building relationships based on mutual respect and understanding.

In governance, leaders prioritize integrity, transparency, and inclusivity. Past woke leaders are humiliated and exiled. New leaders work to build consensus across diverse groups, guided by principles of justice and fairness not woke stupidity.

Imagine political arenas or Town Halls where debates are characterized by

thoughtful analysis and respectful discourse, rather than partisan bickering and ideological posturing.

This model of leadership inspires trust and confidence, fostering a sense of collective responsibility and shared purpose. In this future world wokeness is just a sad memory. Society as hit the reset button for the good of all mankind.

Economic and social policies in this future are grounded in principles of equity and inclusion. Efforts to address systemic inequalities are driven by a commitment to justice and fairness, rather than ideological dogma and self-defeated victim groups. Policymakers adopt evidence-based approaches to social and economic challenges, drawing on a wide range of data and perspectives to inform their decisions not feelings. This pragmatic and inclusive approach ensures that policies are effective, equitable, and reflective of the diverse needs of society.

Imagine a world where the arts and humanities flourish, free from the constraints of ideological conformity. Artists, writers, and performers are encouraged to explore a wide range of themes and ideas, pushing the boundaries of creativity and expression. This cultural renaissance is characterized by a celebration of diversity, where the full spectrum of human experience is honored and explored.

Art serves as a powerful vehicle for fostering empathy and understanding, bridging the gaps that divide us and bringing people together in shared experiences of beauty and meaning.

In this future, technology is leveraged to promote intellectual diversity. Social media and other online platforms are designed to facilitate meaningful conversations and connect people with different perspectives. Algorithms prioritize content that

encourages critical thinking and respectful debate, rather than amplifying outrage and division or pushing brain rot content with absolutely no value. By fostering a healthier digital ecosystem, we can create an online culture that mirrors the values of our post-woke society.

Legal and policy reforms are also essential in this vision. Governments and institutions develop policies that promote social justice while protecting individual rights and freedoms. This involves ensuring that laws and regulations are fair, transparent, and consistently applied to everyone equally, and that they do not unduly infringe on personal liberties.

Imagine a legal landscape where justice is administered with both compassion and rigor, balancing the need for accountability with the principles of fairness and equity.

Promoting mental health and well-being is another crucial aspect of this future. It must always be addressing the underlying emotional and psychological factors that contribute to woke ideological extremism, we can create a more balanced and compassionate society based on science and humanity. Mindfulness and self-reflection become integral parts of daily life, helping individuals cultivate greater awareness and understanding of themselves and others.

Imagine communities where mental health resources are readily available and where seeking help is normalized and encouraged.

Schools and workplaces prioritize mental well-being, providing support and resources for individuals to develop healthy coping mechanisms and resilience. Victimhood is no longer anything anyone wants association with. This holistic approach to mental health fosters a society where people feel supported and empowered to navigate the complexities of life with confidence and

grace. If more people would take the old saying of sticks and stones to heart many of our woke problems would simply disappear.

To achieve this vision, it is essential to promote forgiveness and reconciliation.

This involves recognizing the humanity in each other, even in those with whom we disagree.

By fostering a spirit of forgiveness and understanding, we can heal the wounds of division and create a more cohesive and harmonious society without wokeness.

A world where conflicts are resolved through dialogue and empathy, rather than hostility and retribution.

As we envision this post-woke future, it is important to recognize that the steps towards this vision will be an ongoing and iterative.

Wokeness much like communism is an evil who will fight against our rejection until the bitter end.

It requires a collective effort, a commitment to principles, and a willingness to engage with difficult and contentious issues. So let us start fostering a culture of open dialogue, critical thinking, and mutual respect, we can counteract the homogenizing influence of woke ideology and create a more inclusive, rational, and cohesive society.

The vision of a post-woke future is one where inclusivity and rationality intertwine, creating a society that thrives on open dialogue, critical thinking, and genuine human connection

Doing so, we can ensure that our society values both equality and individual rights, promoting a more just and inclusive future for all free of wokeness.

www.ingramcontent.com/pod-product-compliance
Lightning Source LLC
Chambersburg PA
CBHW071914210526
45479CB00002B/417